POSTCARD HISTORY SERIES

Olympia

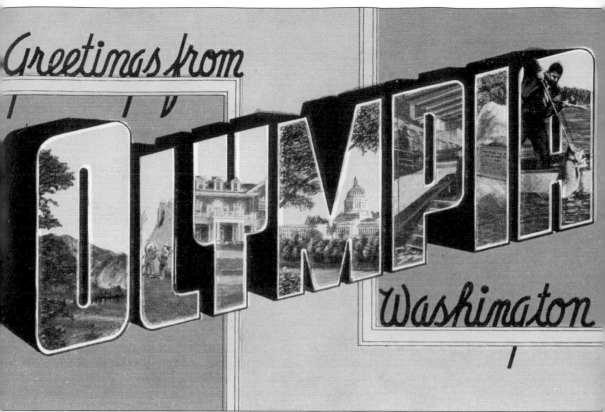

Large-letter linen postcards were popular in the late-1930s and early-1940s, and today they are a popular topic among postcard collectors. Each letter contains a miniature view pertinent to the town or area featured. This "Greetings from Olympia, Washington" card is a good example. A key to the views is printed on the back of the card. "O—Priest-Point Park, L—Yakima Indians and their Tepees, Y—Governor's Mansion, M—State Capitol, P—Making Fir Plywood, I—End of Oregon Trail Marker, and A—Catching A Big One." (Courtesy of Author.)

ON THE COVER: The second state capitol building was completed and ready for occupancy by the time of the 1905 legislative session. The last wing was designed by architect Willis Ritchie and was constructed of Tenino sandstone. Spectators, for the first time, had room in the chambers to witness legislative action. The building structure featured new technical innovations such as steel framing and elevators. Damage suffered in the 1928 fire and the 1949 earthquake resulted in the removal of the 12 towers. (Photograph by Romans Photographic Company, Seattle.)

Olympia

Jill Bullock

ARCADIA
PUBLISHING

Copyright © 2010 by Jill Bullock
ISBN 978-0-7385-8036-4

Published by Arcadia Publishing
Charleston SC, Chicago IL, Portsmouth NH, San Francisco CA

Printed in the United States of America

Library of Congress Control Number: 2009937665

For all general information contact Arcadia Publishing at:
Telephone 843-853-2070
Fax 843-853-0044
E-mail sales@arcadiapublishing.com
For customer service and orders:
Toll-Free 1-888-313-2665

Visit us on the Internet at www.arcadiapublishing.com

This book is dedicated to all the early publishers and photographers who strove to provide the public and their friends with the images that are so loved today by collectors and historians. Thanks to their early work and efforts, history was preserved. Today these eye candy images bring the past alive for all to enjoy.

CONTENTS

ACKNOWLEDGMENTS

Thanks to many good people in the Olympia area who willingly shared stories and provided assistance, including Dale and Tim Rudledge, postmaster Janet Stedman of Littlerock, Tim Pilon of the Washington Fish and Wildlife Department, and Dave Hastings and Mary Hammer of the Washington Secretary of State archives staff. Thanks to Seattle postcard dealer Mike Fairly of Fairlook Antiques, who came up with many wonderful cards and other Olympia ephemera to help make this book possible.

A special thanks to the following postcard collectors who willingly shared their images and expertise in order to significantly enhance this book: Richard and Deleah Smith of Olympia; Richard Dreger of Creston, Washington; Mike and Kathy McLean of Spokane; and Paul and Jeri Longcrier of Olympia. Special thanks to Liz Smith of Olympia for research information she compiled and Sarah Higginbotham and the rest of the staff from Arcadia Publishing for their expertise and technical assistance. Finally, thanks to Tom Mulvaney for his unconditional backing and support and without whom this book would never have been possible.

Unless otherwise noted, all images appear courtesy of the author.

INTRODUCTION

To know and understand the city of Olympia, the capital city of Washington State, it is necessary to have knowledge of her past. Located on the southernmost tip of Puget Sound, the area was the home to many native peoples for hundreds of years prior to its settlement in 1846. By 1853, the town's population had grown to 996; and by the mid-1850s, the development around the waterfront quickly transformed the area into a hub of maritime commerce. Early on, the city became a center of lumber processing; and soon after the turn of the century, the city boasted numerous smokestacks as industry increased along the waterfront.

Major changes were made to the size of the downtown area by dredging and filling during the first two decades of the 20th century. Almost 40 city blocks were added to the downtown area in an effort to create a deepwater harbor and to fill in the sloughs to the north and east of the city. The new real estate was welcomed as well. Who today knows that Plum Street was once a tidal waterway?

Olympia's title of capital was often contested during the early years, but townspeople fought challenges by Vancouver, Steilacoom, Seattle, Port Townsend, and Tacoma for location of the seat of territorial and—later—state government. Its recognition as such gave the town a certain future. It prospered and added amenities like an opera house, city water system, streetcar line, street lamps, and a new hotel to accommodate visiting legislators.

Throughout the years, the state government has been housed in a series of buildings in Olympia, including the former county courthouse in downtown. The increased growth in state government, due in part to the burgeoning population and business of the state, kept the city on a path of forward momentum, growing in size and development.

The 1950s ushered in freeway construction that provided a vital transportation link for Olympia and the Puget Sound region. No longer "off the beaten path," the area witnessed phenomenal growth. Its days as a quiet little city were over.

Visual documentation of Olympia's evolvement during the past century was well covered by the picture postcard, whose usage became very popular with the masses as early as 1905. Many of the early postcards, including most of the images found in this book, are actually photographs developed on postcard stock paper. This type of postcard is known as a real photograph postcard among those in the hobby. A common abbreviation for "real photo postcard" is RPPC, and the term is used throughout the text of this book.

One

STEAMBOATS AND
SHORELINES

The golden age of steamboating served the scattered settlements around Puget Sound and acted as a force drawing them together into a cohesive society. From the end of the pioneer era in 1870 up to the beginning of the gasoline era in 1920, steamboats provided the new frontier with the best means of comfortable travel available at the time.

For gatherings big and small, the steamers of every size served the citizenry. Provisions were moved from place to place, transportation was provided for the people, and the mail was delivered.

For Olympia, the shoreline had great shifts on occasion. Enterprising souls sought to eliminate the shallow mudflats of Budd Inlet and the Swantown Slough, both long a problem for approaching harbor ships. The combined dredge and fill operations through the years added much valuable real estate to downtown while offering a solution to the shipping channel problem. There would no longer be the need for a three-quarter-mile-long wharf. By 1917, the days of the mosquito fleet were ending on the waterways and steamer traffic had dwindled to one small steamer. A new era was about to dawn.

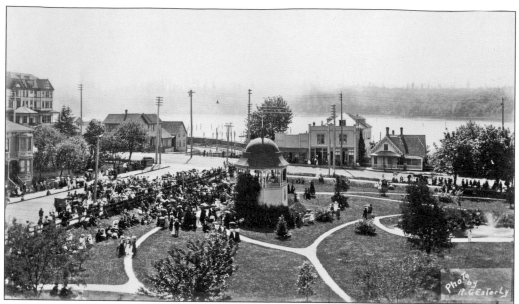

This early photograph shows an Olympia that will be unrecognizable to the viewer today. This is the corner of Sylvester Park where the first gazebo stood. The right foreground shows a portion of the fishpond. The large building to the upper left is the Olympia Hotel. "Where," the perplexed viewer asks, "is downtown?" The answer is surprising to those unfamiliar with the history of the town: "It's out in the bay." In 1870, the northern limit of downtown was Olympia Avenue. Today the Port of Olympia stands on land created by fill, mud dredged from the bay and held behind bulkheads. The land for Sylvester Park was donated to the City of Olympia by Edmund Sylvester at the time he first platted the town in 1850. In 1893, the ornate gazebo, the goldfish pond, and a wrought iron fence were added. (Above courtesy of Washington State Historical Society.)

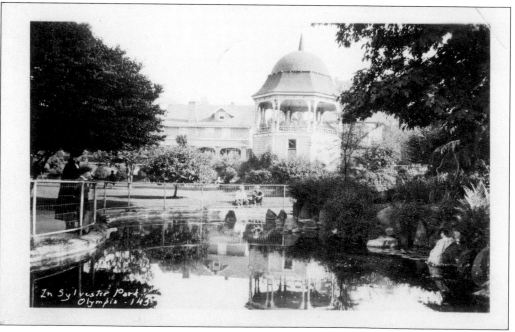

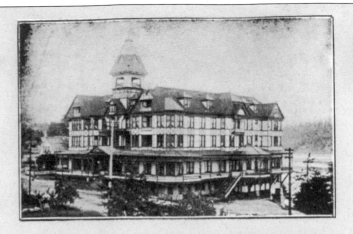

THE OLYMPIA

E. N. TUNIN, *Proprietor*

Headquarters for Commercial Men
Fine Sample Rooms **Olympia, Wash.**

The Olympia Hotel, one of the finest hotels on the West Coast was the pride of the city. It was a masterpiece of Victorian architecture and boasted the first electric lights in Olympia. Above is a forerunner to the contemporary business card. This printed advertisement showing the Olympia was attached to the reverse of a cabinet photograph, shown at right. Mrs. Crandal, identified on the reverse of this photograph as the subject, is dressed in the proper Victorian finery of the day. The photographer W. Duckering may have had his studio in the Olympia Hotel at the time. His advertisement is dated June 15, 1903. The following year, the beautiful Olympia Hotel was consumed in a spectacular fire. In 1907, Duckering's studio was located at the west corner of Seventh Avenue and Main Street.

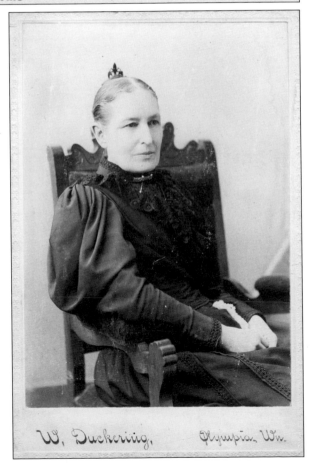

W. Duckering, Olympia, Wn.

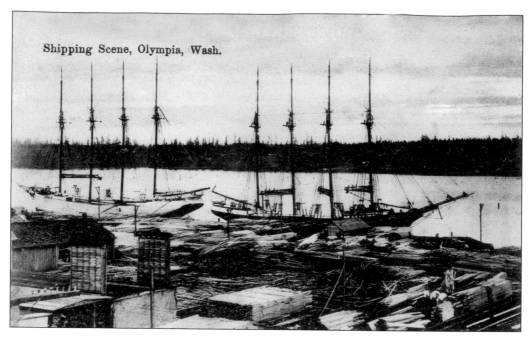

Shipping Scene, Olympia, Wash.

Lumber was a major export from the harbor throughout much of the history of the town. Sailing ships made frequent visits for loads of this valuable cargo, as shown in the shipping scene on the 1909 printed postcard above. The view below shows Olympia from the Westside across the Marshville Bridge looking back toward the town. Note the sparsely developed hillsides. The capitol building is visible in the center of the picture. The Horns and the Percival Docks are to the front left on the far side of the drawbridge. The center front building was a station for the Olympia-Tenino Railroad.

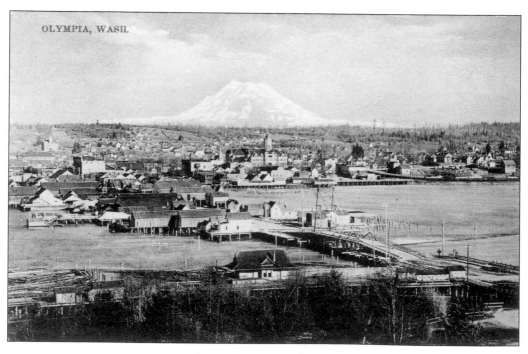

OLYMPIA, WASH.

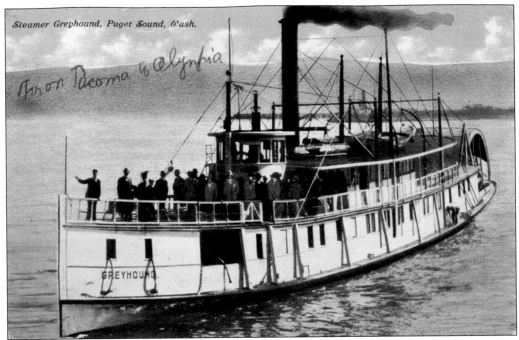

Steamer Greyhound, Puget Sound, Wash.

on Tacoma to Olympia

GREYHOUND

This printed postcard, postmarked 1910, shows the *Greyhound*. Built in 1889, she was one of the fastest ships of her day. She was brought to Puget Sound in 1892 by the Olympia-Tacoma Navigation Company. In 1904, while at Percival Dock, she nearly sank. In the early 1900s, the *Greyhound* traveled the route between Tacoma and Olympia where connections could be made with another steamship, the *Flyer*, for transportation to Seattle.

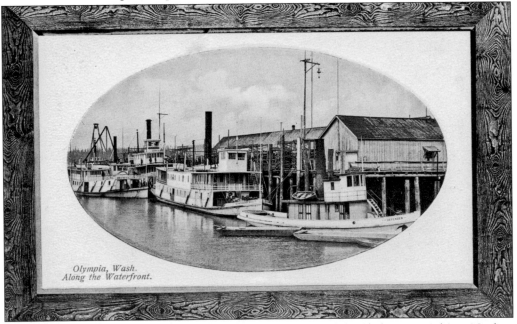

Olympia, Wash.
Along the Waterfront.

This *c.* 1910 printed-postcard view shows the tug *Defender* and the Shelton steamships, *Northern Light*, *City of Shelton*, and *Multnomah* all tied up at the Percival Dock. It is recorded that the *Northern Light* later broke up in Sullivan Slough.

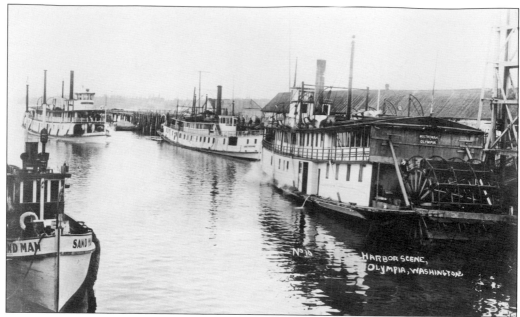

This *c.* 1908 RPPC image reinforces the record of activity at the Olympia harbor a century ago. It was taken at Percival Dock in Olympia showing the steamer *Multnomah* docked in the right foreground followed by the *Greyhound*. The *S. G. Simpson*, visible at the upper left, is just coming into port.

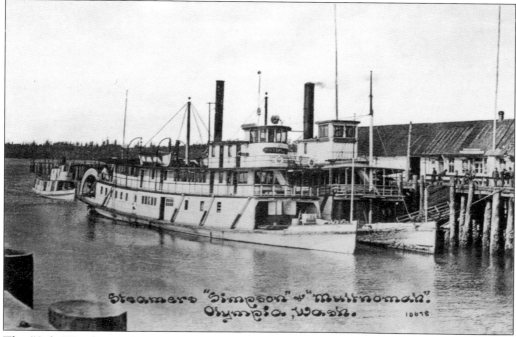

The "Sol G"—the *S. G. Simpson*'s nickname—was one of the last and best-known Shelton boats. Here she is tied up at the Percival Dock, after the deepening of the harbor, with the *Multnomah*. Both steamboats, shown here in a *c.* 1910 postcard, were owned by the S. Willey Navigation Company.

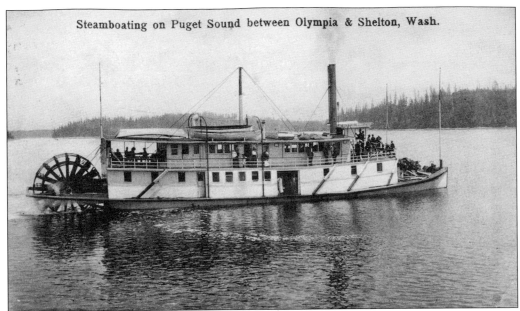

Steamboating on Puget Sound between Olympia & Shelton, Wash.

The *City of Shelton*, another of the last well-known Shelton boats, succeeded the SS *Willie* on the Olympia-Shelton route at the turn of the century. She was operated by the S. Willey Navigation Company, owned by Lan and Lafe Willey, sons of logger and early settler Sam Willey. Shown here in a *c.* 1910 postcard view, the *City of Shelton* was used as a spare boat until being sold in 1912.

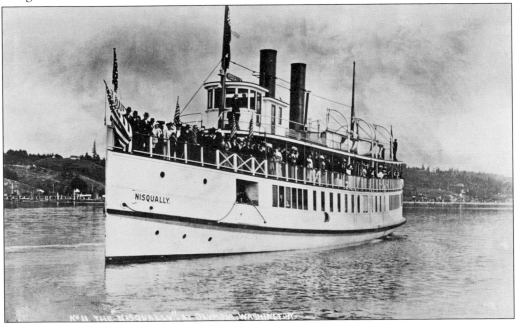

In 1911, the new propeller-steamer *Nisqually* replaced the *Greyhound* on the Olympia-Tacoma route. For a fee of 50¢, passengers could make the trip in two hours, even with the ship running against the tide. Her days were short as by 1917, the steamboat era was fast ending. Renamed the *Astoria* in 1918, she was moved to the Columbia River only later to be sunk in 1923 in Seattle.

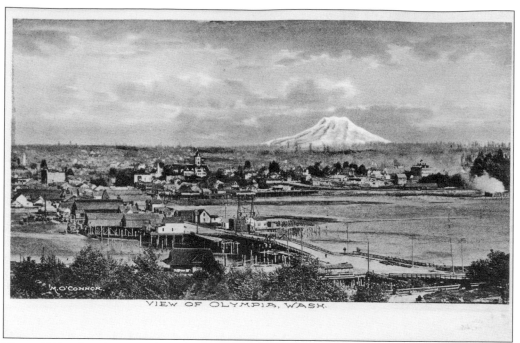

VIEW OF OLYMPIA, WASH.

The *c.* 1910 printed-postcard view above records a view from the Westside of Olympia looking across the Marshville Bridge. The state capitol is to the left of center. Note the plume of smoke at the center right border. This was the Shingle Mill. The Northern Pacific Railroad Depot stands to the left of the Shingle Mill. The mountain, then known as Tacoma, looms in the background. Today it is better known as Mount Rainier. Looking from the southwest, the lower *c.* 1910 postcard view gives a better look at where the Shingle Mill was located and a look at the log boom used to contain the raw logs before processing.

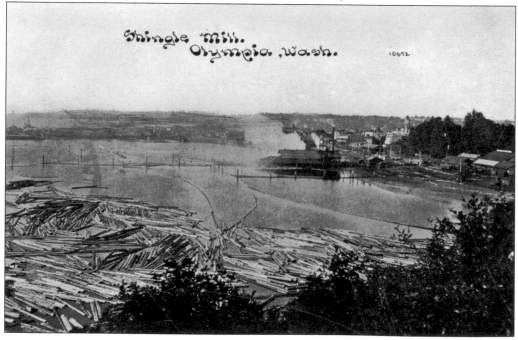

Shingle Mill. Olympia, Wash.

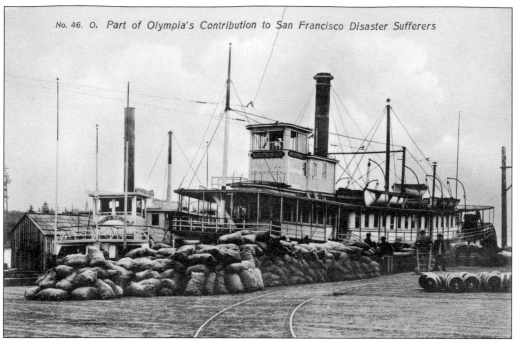

This printed-postcard view shows the steamships *City of Shelton* and the *Multnomah* tied up dockside in the Olympia harbor. In the foreground are supplies that are "Part of Olympia's Contribution to San Francisco Disaster Sufferers." The aid was destined to help San Francisco residents, whose city had been devastated by the earthquakes and ensuing fires in 1906. (Courtesy of Paul Longcrier.)

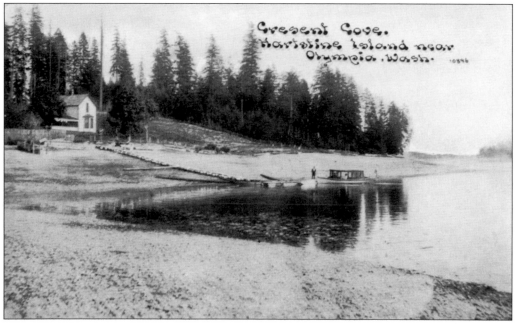

Boaters are visible docking at Crescent Cove on Harstine Island near Olympia. This area has not changed much over the past century. It remains mostly undeveloped and heavily timbered. The shoreline today closely resembles the scene shown in this *c.* 1907 postcard.

17

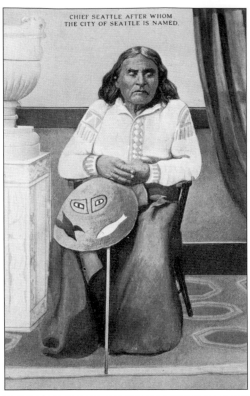

Few people today realize that Chief Seattle was living in the Olympia region when the white man arrived and that he was baptized near Olympia in the Catholic church after the death of one of his sons. It was in Olympia that he met Dr. David S. Maynard and the two became good friends. Chief Seattle saved "Doc" Maynard from an assassination attempt and helped protect the small band of European American settlers in what is now Seattle from other Native American attacks. Because of Seattle's friendship and help, at the urging of Doc Maynard, the settlers named their newly born city after him.

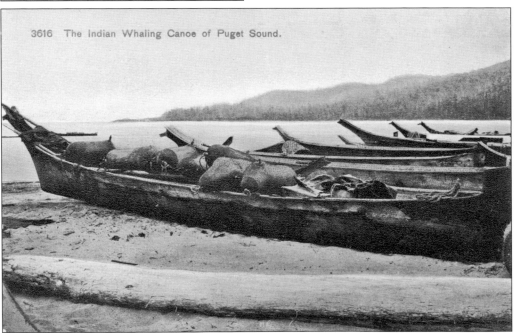

3616 The Indian Whaling Canoe of Puget Sound.

The story goes that Judge O. B. McFadden, an early-day delegate to Congress, defeated his seated opponent, Selucious Garfielde, in a rather unorthodox manner. McFadden campaigned around the Sound in canoes paddled by Native Americans. Garfielde, who was a well-known orator of his time, moved to the national arena in the McKinley campaign for president.

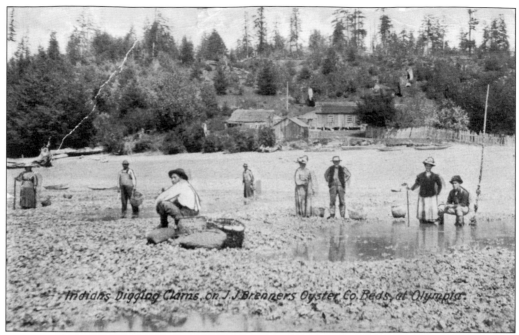

Indians Digging Clams, on J. J. Brenners Oyster Co. Beds, at Olympia.

The Olympia harbor of today does not resemble the pioneer-day waterfront where Duwamish Indians dug clams along the tidal beaches, as shown in the above image. In 1893, the J. J. Brenner family established an oyster processing plant on East Fourth Avenue. In 1951, oystermen moved their processing plants to Oyster Bay to be closer to the beds. The mailing side of this postcard is shown below. Text on the left side of the card advertises the low cost, high quality, and fast order processing provided by the J. J. Brenner Oyster Company for the "rapidly approaching" oyster season. The top of the message is dated August 20, 1912. The card was postmarked from Olympia the following day. (Courtesy of Paul Longcrier.)

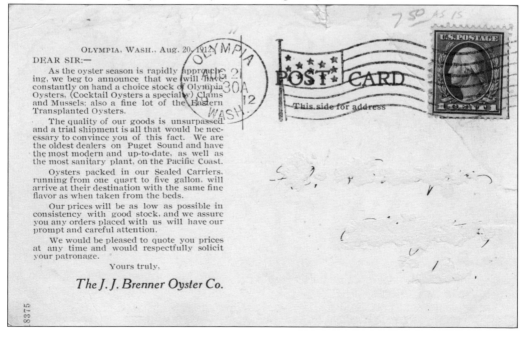

OLYMPIA, WASH., Aug. 20, 1912

DEAR SIR:—

As the oyster season is rapidly approach-ing, we beg to announce that we will have constantly on hand a choice stock of Olympia Oysters, (Cocktail Oysters a specialty) Clams and Mussels; also a fine lot of the Eastern Transplanted Oysters.

The quality of our goods is unsurpassed and a trial shipment is all that would be nec-essary to convince you of this fact. We are the oldest dealers on Puget Sound and have the most modern and up-to-date, as well as the most sanitary plant, on the Pacific Coast.

Oysters packed in our Sealed Carriers, running from one quart to five gallon, will arrive at their destination with the same fine flavor as when taken from the beds.

Our prices will be as low as possible in consistency with good stock, and we assure you any orders placed with us will have our prompt and careful attention.

We would be pleased to quote you prices at any time and would respectfully solicit your patronage.

Yours truly,

The J. J. Brenner Oyster Co.

POST CARD

This side for address

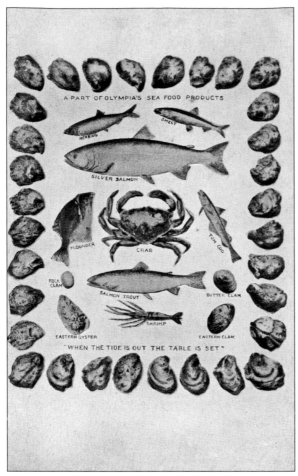

In 1900, Olympia was the headquarters on Puget Sound for products from the sea. Claims were made that the water contained sufficient salmon, halibut, cod, and many other fish to supply the whole country. Early settlers quickly took to viewing the oysters, clams, and shellfish as a natural resource to exploit for profit. This *c.* 1910 postcard supported that premise. Part of the caption includes the old pioneer saying, "When the tide is out, the table is set."

Many early-day political maneuvers were reportedly devised in Doane's Oyster House over plates of his secret and guarded recipe of oyster pan roast. Famous not only in Olympia, this eatery was a "must stop" for travelers from everywhere who visited the Pacific Northwest. Foreign visitors from Europe helped ensure the widespread word-of-mouth advertising. This *c.* 1930 postcard view shows the rather plain café exterior. Nonetheless, Doane's is credited with helping to make Olympia oysters famous.

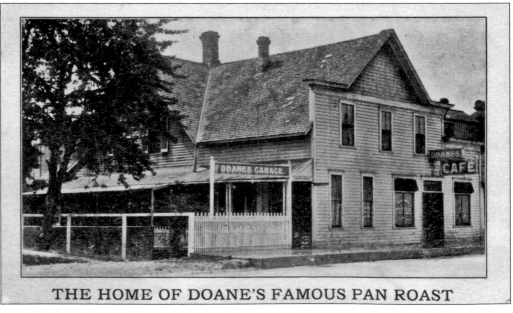

THE HOME OF DOANE'S FAMOUS PAN ROAST

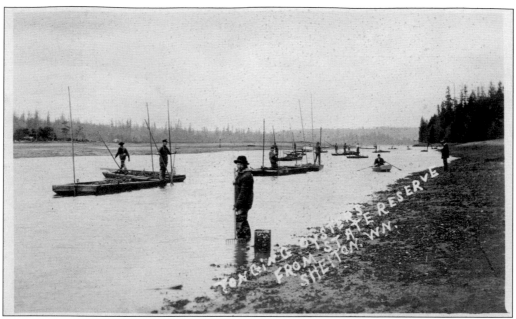

Captioned, "Tonging Oysters From State Reserve, Shelton Wn.," this RPPC was mailed from Shelton in 1910. The message penned on the back reads in part, "Here is where I am again after oyster seed to transplant to our own beds about 30 miles away? Had my crew together yesterday and scows ready to work but the (wind) blew so strong we could no do anything, and it poured down rain." From the time Native Americans first inhabited Lower Puget Sound, the oyster was an important part of the culture as well as an additional food source. A brisk trade soon developed. In 1889, oystermen sent their products to eastern Washington to act as the "succulent lobbyists" to acquire votes for Olympia during the drive to make the city the state capital. The 1890s saw the development of oyster boats and rafts, like the one shown in the c. 1910 postcard image below, for washing the harvest. (Above courtesy of Richard Dreger.)

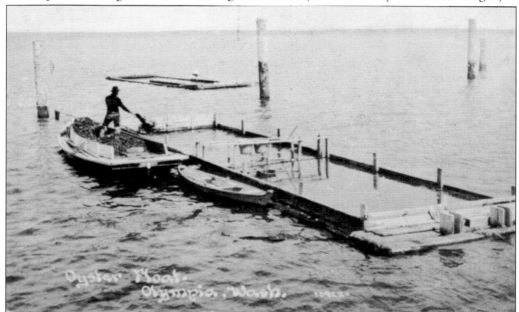

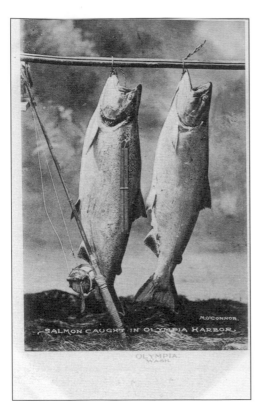

"Salmon Caught in Olympia Harbor," this *c.* 1907 printed postcard was retailed by the Michael O'Conner Stationery Store in the downtown Woodruff Building. (Courtesy of Paul Longcrier.)

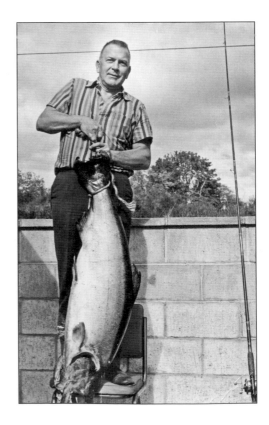

This RPPC, postmarked from Olympia on August 3, 1966, shows that the big fish could still be caught.

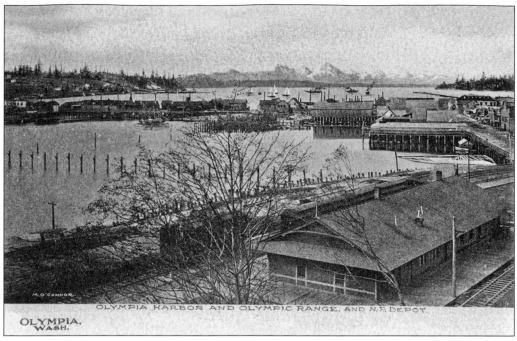

This *c.* 1910 printed postcard of the "Olympia Harbor and Olympic Range and N.P. Depot," shows the Olympic Mountains as visible from downtown. The mountains are the town's namesake. The Northern Pacific Depot is visible at lower right. This card was published and retailed by the Michael O'Conner Stationery Store downtown.

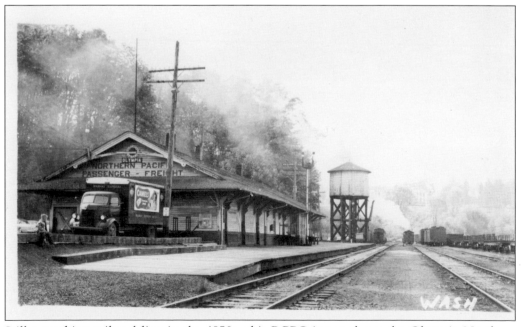

Still a working railroad line in the 1950s, this RPPC image shows the Olympia Northern Pacific Railroad Passenger and Freight Depot. (Courtesy of Paul Longcrier.)

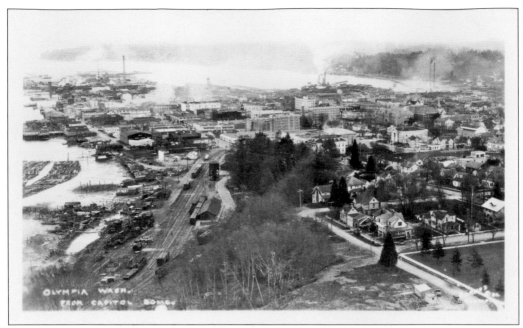

Taken from the dome of the new state capitol building, this *c.* 1930 RPPC view shows the Northern Pacific Railroad Depot with the rail yard in the left section of the image. The background waterfront is developing with industry, and the smoke billows into the air. (Courtesy of Paul Longcrier.)

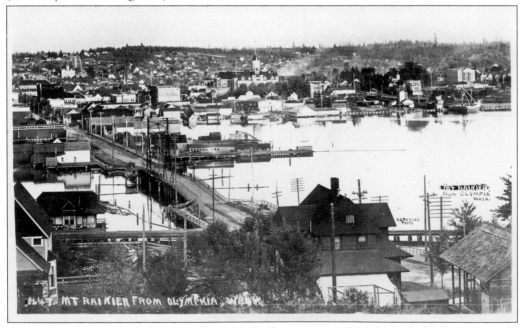

This *c.* 1915 RPPC shows a nice view of the developing town. The first draw-span bridge built in 1869 was faulty and subject to worms, so it was replaced in 1891. In 1905, subject to the same litany of problems, that bridge was replaced with the bridge shown. The card is captioned, "Mt Rainier from Olympia, Wash." The famous mountain failed to appear for its portrait that day due to overcast skies.

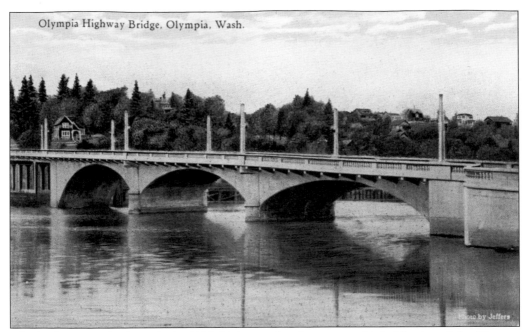

Olympia Highway Bridge, Olympia, Wash.

Photo by Jeffers

The bridge was rebuilt again in 1921. Being made of concrete, this bridge lasted for 80 years and was an area landmark known simply as "the Fourth Avenue Bridge." On February 28, 2001, the 6.9-magnitude Nisqually earthquake struck, and the bridge became the most visible casualty. Many of its ornate balusters crumbled, and after an inspection the underpinnings were also found damaged beyond safe use or repair.

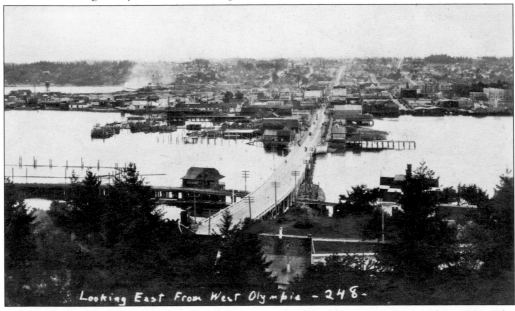

Looking East From West Olympia - 248 -

Postmarked 1925, this RPPC shows the concrete bridge that was constructed in 1921. The railroad passes underneath as it heads up the bay for the industrial area and the site of what had been the shipbuilding yards. The peninsula area behind Percival Dock is filled with industry and warehouses. Roads run up the far hillsides to accommodate the many homes that have been constructed.

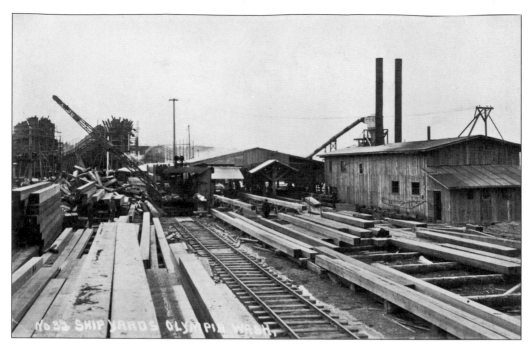

The Sloan Shipbuilding Company acquired this shipyard on the Olympia waterfront in 1918, and it was quickly developed into an 18-way yard for the building of warships for the U.S. government's First World War effort. The story of this undertaking is filled with controversy, litigation, and tragedy. No ships were ever completed. They were sunk in 1920 after being towed out into the bay and burned. The upper *c.* 1920 RPPC is a view taken at the "Ship Yards, Olympia, Wash." The lower *c.* 1920 RPPC is an image that gives the viewer an impression of the sheer size and scale of these boats under construction.

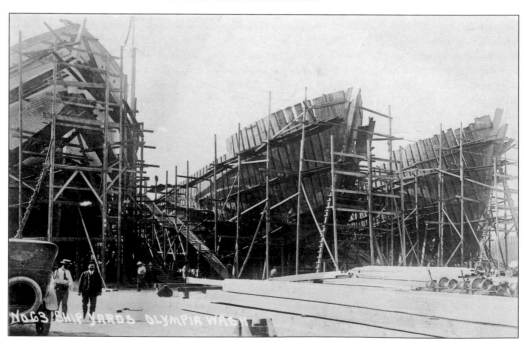

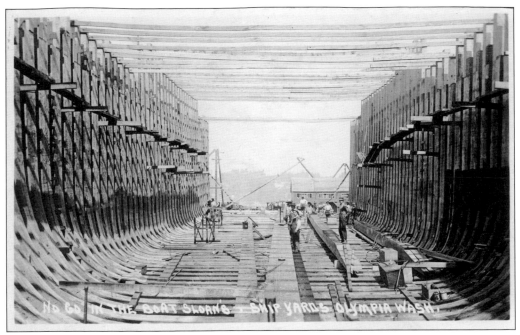

This *c.* 1920 RPPC shows a ship being built from the inside, illustrating the details of hull construction. (Courtesy of Richard Dreger.)

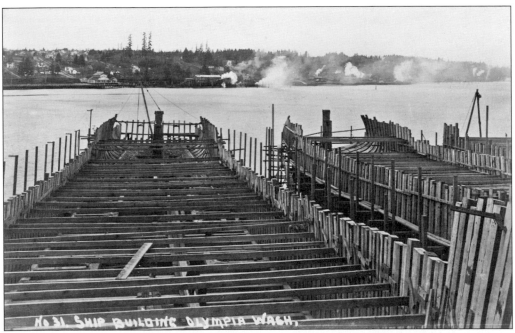

Taken from the dock area, this *c.* 1920 RPPC view looks out across the berths where hulls are under construction. It also shows the industrial operations across the bay.

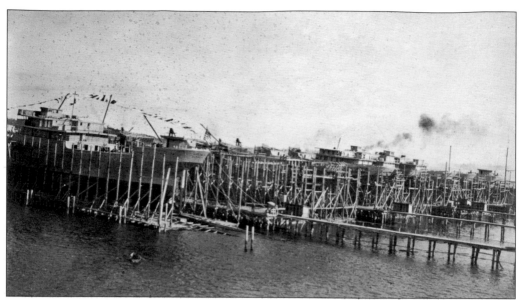

The image shown in this RPPC, also of *c.* 1920 vintage, was taken from a vantage point looking down the line of the berths in the shipbuilding area. Vessels can be seen in various stages of progress. (Courtesy of Paul Longcrier.)

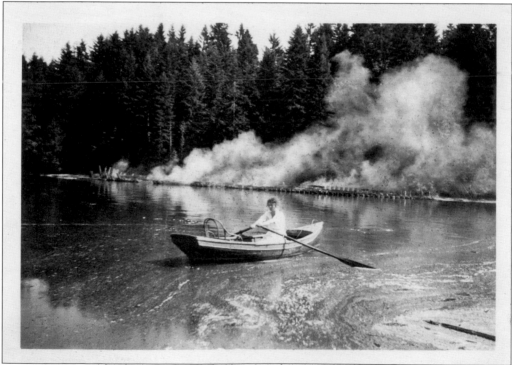

This is a rare, historical view showing the burning of an unfinished ship that had been under construction at the Sloan Shipbuilding Company for the World War 1 effort. The notated message on reverse says, "Myself in rowboat down at Butlers Cove, 1920—Unfinished battleship being destroyed after First World War." The woman in the boat was Frieda Struck. (Courtesy of Jeri Longcrier.)

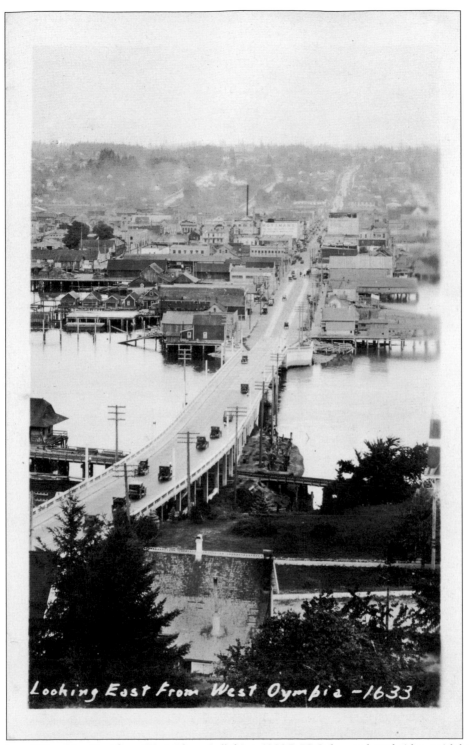

Captioned "Looking East from West Olympia," this *c.* 1928 RPPC shows a busy bridge, with heavy car traffic for the time period. The railroad tracks run underneath the bridge in the foreground, and the edge of the Olympia-Tenino Railroad Depot is visible in the center left border.

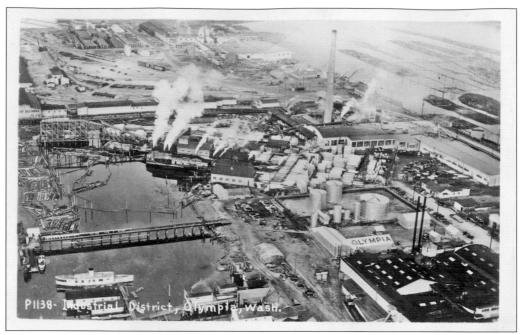

This aerial RPPC view, postmarked in 1947, shows the commercial development in the industrial district at the Port of Olympia. The tall smokestack of the Washington Veneer Company evidences a time in the city's past.

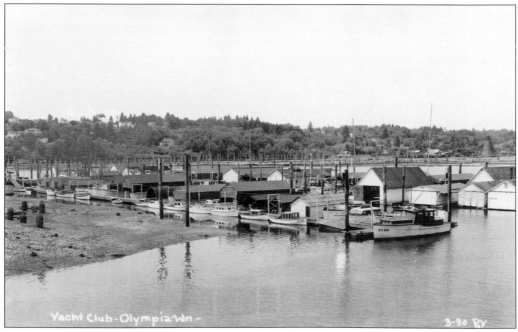

Founded in 1904 as the Boat and Rowing Club of Olympia, the organization was formally renamed the Olympia Yacht Club in 1916. Around 1940, the club moved to an East Bay moorage. This *c.* 1945 RPPC view shows a sampling of the club's yachts. The club's mission statement is, "to encourage and promote yachting, the science of seamanship and navigation, and to provide and maintain suitable facilities for the use and recreation of its members."

Two

DOWNTOWN

In 1889, Washington gained statehood and the citizens of Olympia began a new fight. This time it was the struggle to get their city named the state capital. The law required a statewide vote requiring a majority of all votes cast. The first vote failed to give Olympia the required tally, leaving the Olympians to face another vote in 1890.

Fate intervened in the form of the great Seattle fire that threatened to consume the city. The Olympia city fathers were quick to act. They sent the town's fine, new steam-pumper fire engine the Silsby to stricken Seattle on the fast steamer *Fleetwood*.

In spite of grumbling amongst the townspeople, $500 of taxpayers' money was also given to Seattle to aid in their recovery. Seattleites, feeling indebted, showed their appreciation by supporting Olympia as the site of a permanent state capitol.

In the 1890 election, Olympia triumphed and sealed her destiny to always be a site of great importance to the state of Washington. Her population was 4,698 at the time. Her future was bright, and there was much building to be done.

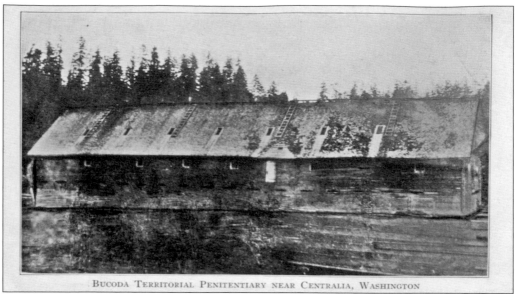

BUCODA TERRITORIAL PENITENTIARY NEAR CENTRALIA, WASHINGTON

Seatco, a Chinook Indian word meaning devil or ghost, was the first name for the town that is called Bucoda today. The first penitentiary in Washington was located there, built in 1874. This 1910 printed postcard shows the timber prison, with its well-spiked 12-inch walls, that was constructed to house the convicts. The prisoners were used for contract labor. This practice continued until 1888. Prison conditions were grim and complaints of inhuman treatment surfaced repeatedly, making the topic a hot political issue at the time. (Courtesy of Paul Longcrier.)

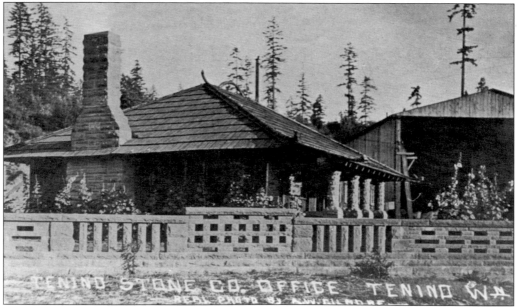

When the sandstone quarries in Tenino began operation in 1888, this town—located about 15 miles southeast of Olympia—became an important center of commerce. Millions of tons were shipped out yearly. Many of the state's most important buildings were constructed using the sandstone from this site. The material remained a choice building product up until the time it was replaced with concrete and steel. This *c.* 1900 photograph shows the office of the Tenino Stone Company.

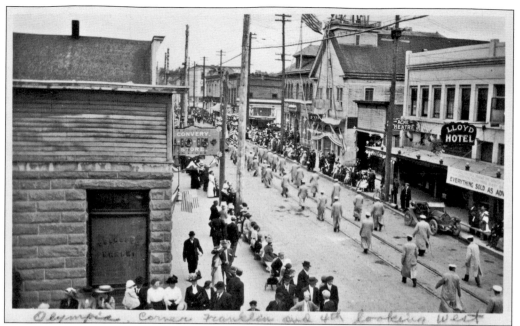

Olympia, Corner Franklin and 4th looking West

This 1912 RPPC, featuring a parade in progress in downtown Olympia, was taken from the corner of Franklin Street and Fourth Avenue, looking west. The Convery 5-10-25¢ Store is in the left foreground. Across the street, the Lloyd Hotel and the Acme Theatre can be seen. Near the right center is the flag-festooned "Columbia Hall," which housed the city and fire department offices and the city council chambers. In the 1880s, most Olympians picked up their mail at this building. The second floor was used as an opera house, theatre, and ballroom. In 1914, it was destroyed by fire, and today the Columbia Building stands at that site. (Courtesy of Richard Dreger.)

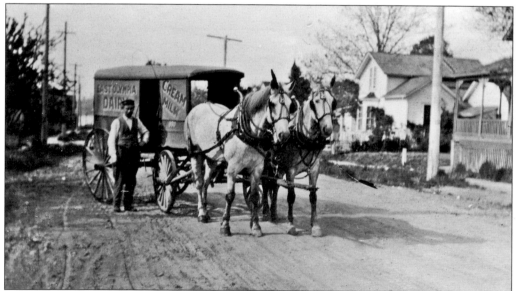

A delivery man poses with his horse-drawn wagon, presumably on a residential dirt street in East Olympia, about a century ago. The wording "East Olympia Dairy" and "Cream Milk" is clearly visible on the side of the wagon, as shown on this *c.* 1910 RPPC. (Courtesy of Richard Dreger.)

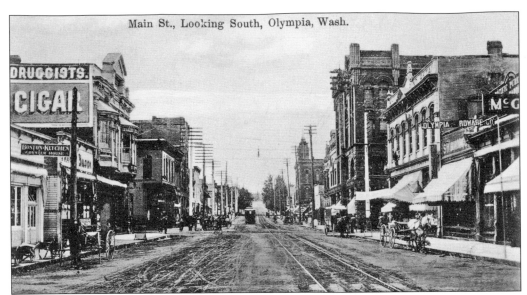

Main St., Looking South, Olympia, Wash.

The *c.* 1907 printed postcard above shows Main Street, today known as Capitol Way, looking south. The Boston Kitchen and Oyster House is visible at the far left, and on the right is the Olympia Hardware Company. The two-story building next door is the Mottman building, originally constructed in 1882 and purchased by George Mottman in 1896. The building was extensively remodeled in 1911 and a third story was added. The store had a pulley-drawn system of overhead baskets that was used to transport purchase payments upstairs to the cashier. It then returned with the customer's change and receipt. That old-fashioned payment system lingers in the fondest memories of today's older local residents. The building also contained the first elevator in Olympia. The image below, taken from a *c.* 1920 RPPC, shows the Mottman Mercantile building at the right, its third story now added. The building next to the Mercantile is the Kneeland Hotel, and the building with the tall tower down the street is the Independent Order of Odd Fellows (IOOF).

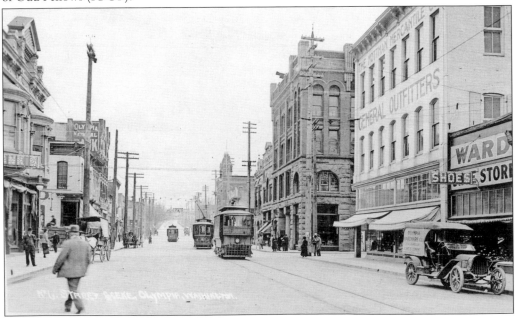

Opened as a first-class hotel on New Year's Day in 1907, the Kneeland featured 34 "all outside" rooms, many with baths. An elevator transported occupants up and down the four floors and telephones were installed in rooms. In 1910, the building's owners, "in the war against sin," brought suit charging the lessees with allowing the hotel to become "disorderly" since the halls were being frequented by women from the restricted district. Liquor was reportedly served at night in rooms. The Kneeland survived until it was demolished after incurring heavy damage in the 1949 earthquake. (Courtesy of Paul Longcrier.)

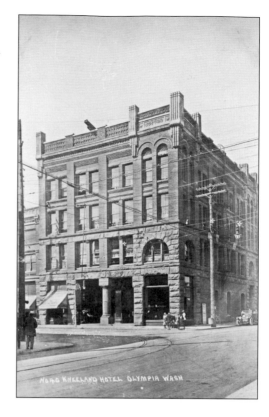

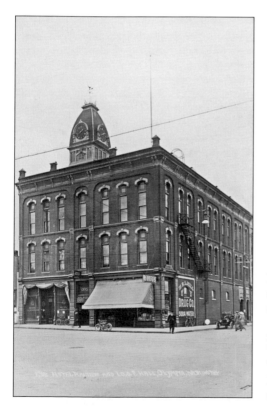

Built in 1888, the Odd Fellows Hall, at three stories, was the tallest building in town for many years until it was destroyed by fire in 1936. It was the site of Washington's first inaugural ball in November 1889. Note the Western Union Telegram motorcycle in front. The building was also home to the Hotel Rainier and the Rexall Drug Store in this *c.* 1915 RPPC. (Courtesy of Paul Longcrier.)

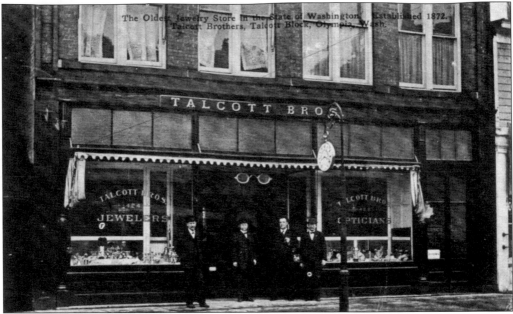

Talcott Jewelers bills itself as "The Oldest Jewelry Store in the State of Washington—Established 1872." The two postcards here of Talcott Brothers Jewelers show the exterior and interior of the store. It was located in the Talcott Block. The jewelry store shared a storefront with the brothers' other business, "Talcott Bros. Opticians." The jewelry store was founded by Lucius Ford Talcott and his son Charles. Charles, George, and Grant Talcott designed and manufactured the Washington state seal in 1889. The store's inventory included a large selection of ornate clocks, which are visible in the display case in the foreground. Before long, the store was offering a comprehensive line of merchandise from bicycles to sewing machines along with the more traditional tableware. (Courtesy of Richard Dreger.)

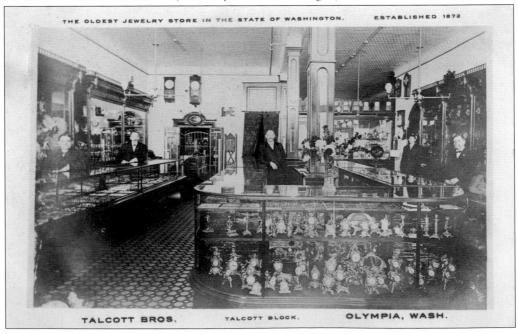

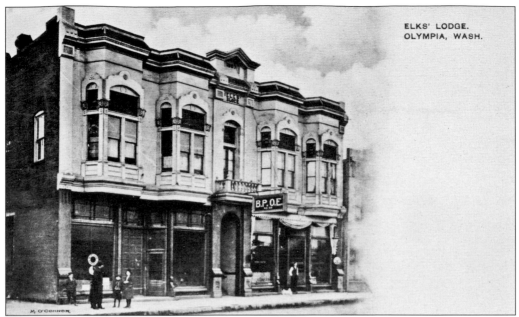

Elkdom, in Olympia, began as Capitol Lodge No. 186 with the installation of Judge T. N. Allen as the first exalted ruler on New Year's Eve 1896. Loss in membership forced the surrender of the charter before the end of the 1897–1898 lodge year. It was reorganized in 1903, as BPOE (Benevolent and Protective Order of Elks) No. 186. G. C. Winstanley, by a vote of the charter membership, was installed as the new exalted ruler. This building, as shown in the *c.* 1910 printed-postcard view above, continued to serve as home for the Elks Fraternal Order until they moved to new quarters. After remodeling, it was then converted for use as an apartment and street-front business, at Capitol Way and Third Avenue. In 1919, they moved to their new site on Capitol Way across from Sylvester Park as shown in the lower *c.* 1920 RPPC image. They remained in this new building until the 1950s.

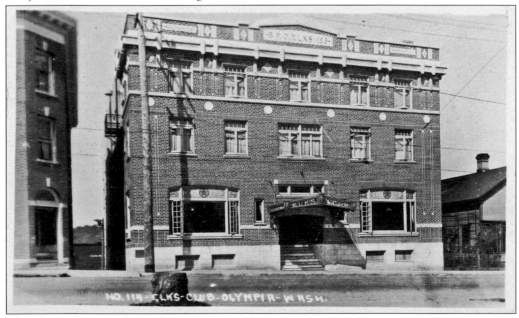

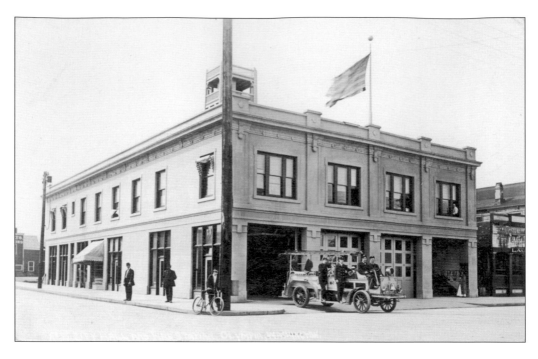

Constructed in 1912, the firehouse additionally served as city hall and housed all of the functions of the city government. This dual use continued until a new city hall was built in 1966. The fire department was the first such formed in the state. This engine was called "Columbia No. 1" after the trade name of the engine's manufacturer, and it was much marveled, giving great prestige to the firefighters. The lower image shows the Columbia No. 1—the new and modern way—next to the fire company's old horse-drawn fire wagon. (Courtesy of Paul Longcrier.)

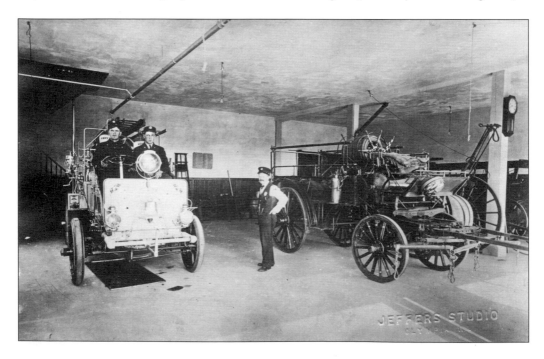

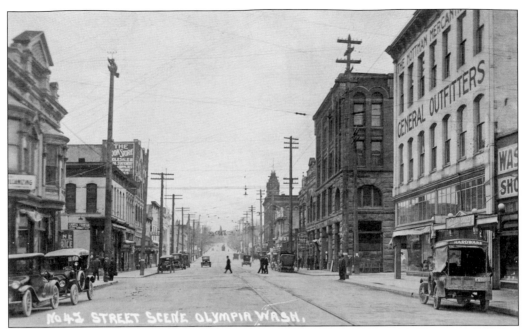

No. 43 STREET SCENE OLYMPIA WASH.

On the right in this *c.* 1920 RPPC image above taken on Capitol Way, the Mottman Building can be seen after the third story was added. Most of the buildings on that side of the street in the next block were destroyed by the 1949 earthquake.

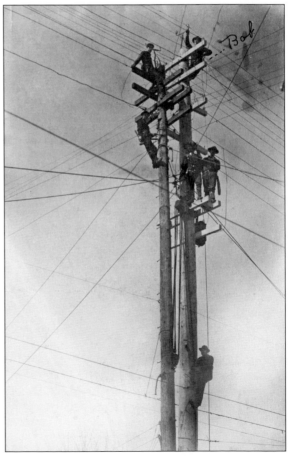

Linemen are posing for a picture in this RPPC view, postmarked from Olympia in 1909. An excerpt from the message penned on the back says, "What do you think of Rob, rather high in the air for a picture?" Bob (or Rob) is identified at the top of the pole in the image. Olympia was blessed with an ample source of "juice" when the Olympia Light and Power Company powerhouse was completed in 1905 on the Deschutes River lower falls in Tumwater.

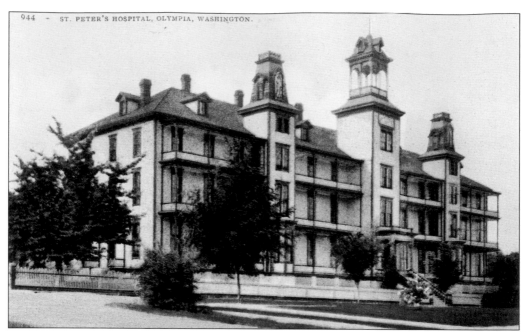

The Sisters of Charity built the original St. Peter's Hospital on land donated by Edmund Sylvester. It opened for patients in 1887. It provided care for local residents and its service was of vital importance for victims of catastrophic accidents in the mills and logging camps. It was demolished in the 1920s to allow expansion on the capitol campus. Its original location is marked by the Indian Story Pole on the present capitol grounds. A new hospital was built on the west side of Olympia.

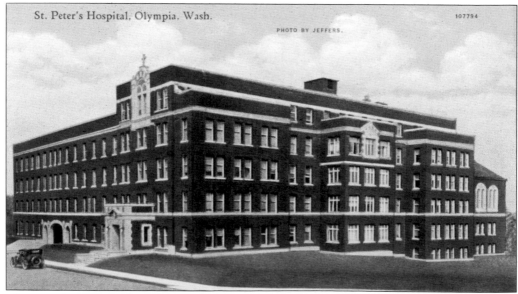

This was the second structure to serve as St. Peter's Hospital. It was built in 1924 when the capitol grounds expanded. Located at Fourth Avenue and South Sherman Street, the hospital was owned and operated by the Sisters of Providence. It was the first large hospital facility in Olympia. In 1973, this hospital was remodeled and transformed into Capitol House Apartments, providing low-cost housing for senior citizens.

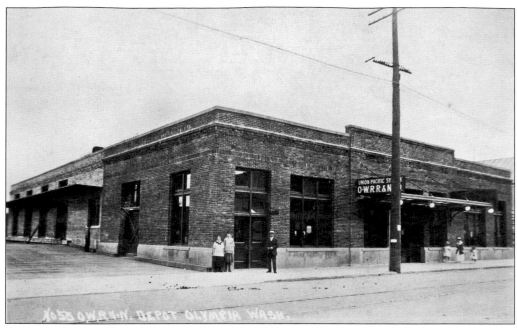

This *c.* 1910 RPPC image shows the Oregon Washington Railroad and Navigation Company Depot located downtown on Fourth Avenue. At the turn of the century, this company operated steamboat service. The RPPC, below, taken in 1910, shows Arlitt's Bakery, which was located at street level in the old Olympia Opera House facility. The building had been constructed in 1890 by newspaperman John Miller Murphy. It sat on pilings near Fourth Avenue and Cherry Street over the Swantown Slough. Up until that time, the area stretching from today's Marine Drive on the north and southward to Eighth Avenue was a mudflat tidal inlet. It extended from approximately Cherry Street on the west to Plum Street of today. It once divided downtown from the Eastside neighborhood. Harbor dredging in the 1920s filled the area in, and the building fell to the wrecking ball in 1925. (Both courtesy of Paul Longcrier.)

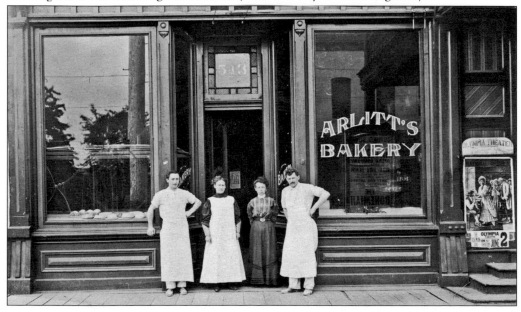

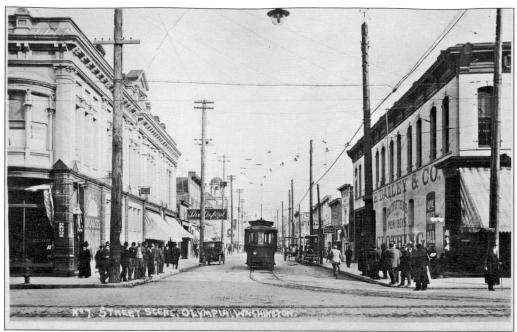

In 1887, Olympia mayor A. H. Chambers built the Chamber Block, one of the city's oldest remaining business blocks. The building sits on historic ground that was once the location of the new settlement's first water pump, a pioneer meeting and gathering place. At the time of the 1855–1856 Indian War, the town placed its cannon at the site. Above, the *c.* 1918 RPPC shows the building in its early days. The earthquake of 1949 did much damage to the exterior façade of the building, including the large bay windows and the elaborate cornice trim features. In the lower *c.* 1950 RPPC image, the left foreground shows the building very shortly after the repair. Note the new roofline.

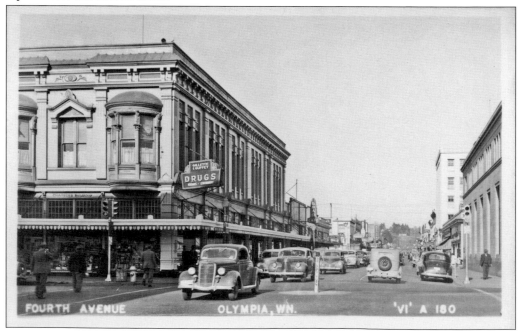

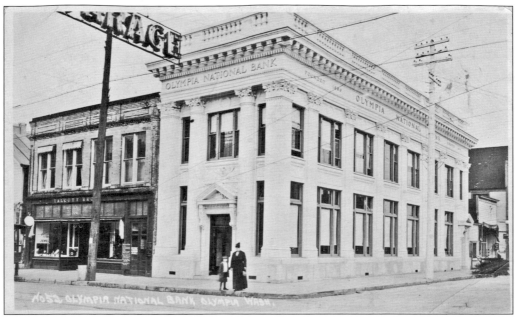

In the early 20th century, the classic style of architecture was used to design "banks as temples." This bank, where Leopold Schmidt was president, is a fine example of such. The style includes Greek columns, an outstanding roofline, and parapets. Originally named the First National Bank of Olympia, it was restored with a fiberglass roof facade and became the Pacific First Federal Savings Bank in 1977. The above 1919 RPPC image shows the bank, located at 422 South Capitol Way, shortly after it was built in 1914. The lower *c.* 1945 RPPC image of Fifth Avenue indicates that finding a parking spot was probably a challenge. The Olympia National Bank building is at left. Farther down the street is the Capitol Theatre, with its domed-top sign and marquee visible. Built originally as a vaudeville house, the movie theater opened in 1924 when "talkies" came into vogue. (Above courtesy of Paul Longcrier.)

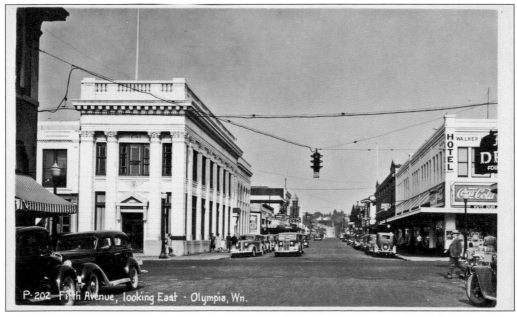

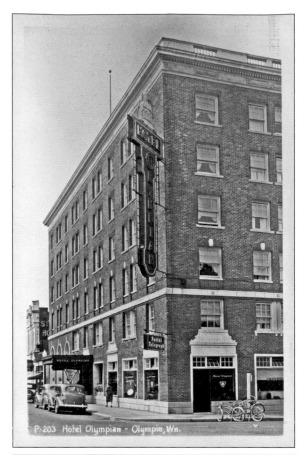

P-203 Hotel Olympian - Olympia, Wn.

Opened in 1920, this hotel, a favorite of politicians, was the site of famous intrigue and bedlam in Prohibition days. Often called the "second capitol," a place of boozy doings, it was a place where political deals were sealed. Controversy and angst resulted amongst legislators when infighting led to a real Prohibition raid. The view at left is a pre-earthquake RPPC image that gives a good showing of the ornamentation on the building roof. The lower view is an after earthquake RPPC image, showing the damaged building with a new roofline.

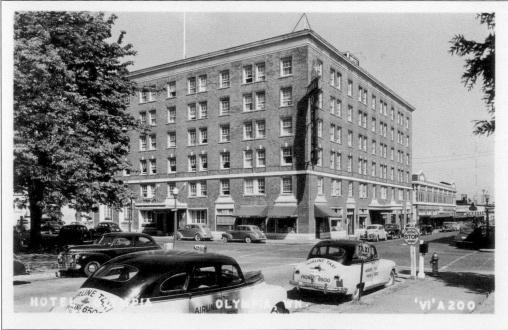

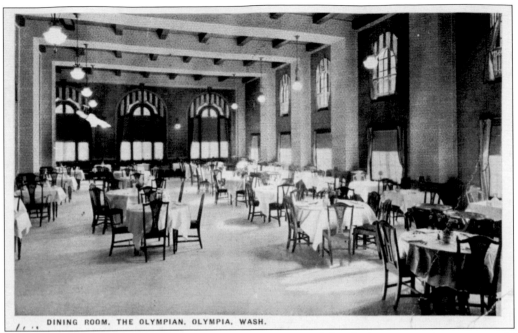

DINING ROOM, THE OLYMPIAN, OLYMPIA, WASH.

Postmarked 1923, this postcard shows an interior view of the dining room where one could enjoy a meal in peace and quiet at the time. The message penned on the reverse side says in part, "Here is a swell place to eat when in Olympia if you want to pay 2 prices for what you eat."

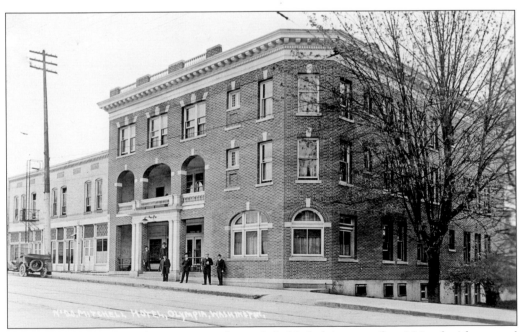

The Mitchell Hotel was first constructed as a desirable lodging spot for visiting legislators and lobbyists. The building, located conveniently on Capitol Way, survived multiple transitions before becoming annexed into the Governor Hotel.

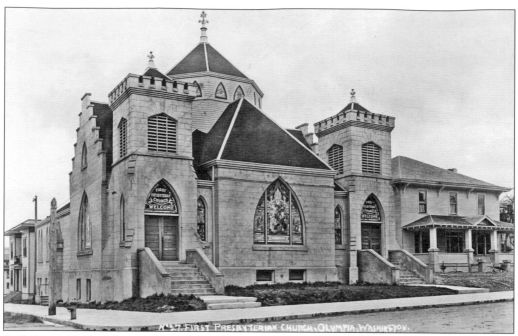

Built in 1862, the First Presbyterian Church was located on the southeast corner of Legion Way and Franklin Street. It was the first church of this denomination organized north of the Columbia River.

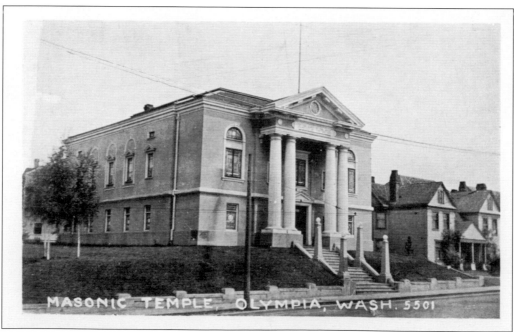

The old Masonic Temple used in territorial days was razed in 1911. A new Masonic Temple was built on the same site at the corner of Eighth Avenue and Capitol Way on land donated by Edmund Sylvester, and it stood until 1971. This printed postcard dates from about 1920.

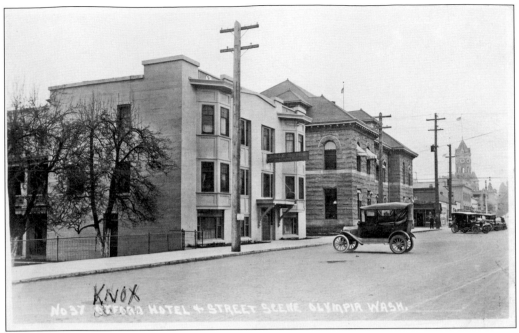

KNOX

NO 37 OXFORD HOTEL & STREET SCENE OLYMPIA WASH.

The image for this *c.* 1915 RPPC shows the Knox Hotel, which Mrs. J. D. Knox had built in 1908 on Washington Street. None of us today remember the time when the new "automobile" was legally parked in the center of the street. Across the street corner to the right, the Thurston County Courthouse can be seen and visible down the block is the clock tower on the then Washington State Capitol building.

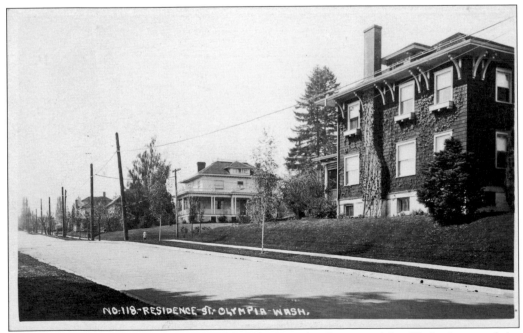

NO. 118 RESIDENCE ST. OLYMPIA WASH.

In this *c.* 1920 RPPC, the ivy-covered building in the foreground is still the home of the YMCA. The building is located near Union Avenue and Franklin Street.

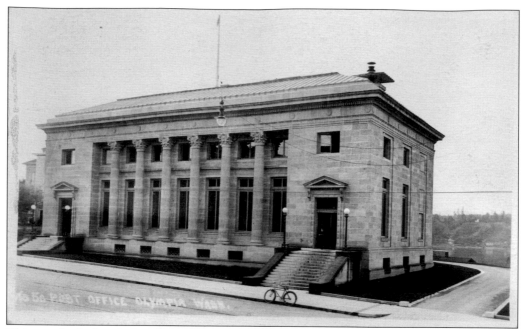

This neoclassical revival–style building, constructed during the years 1912 to 1914, was the first building constructed in Olympia to be specifically used as a post office. It served that purpose until 1964. This *c.* 1915 RPPC shows the post office shortly after it opened. This building stands at Capitol Way and Valencia Street, and after extensive remodeling, it houses several individual businesses today.

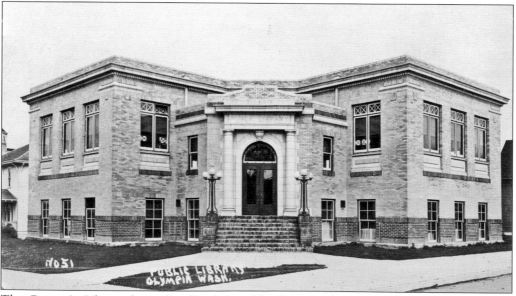

The Carnegie Library, located at South Franklin Street and East Seventh Avenue, is shown in this *c.* 1915 RPPC view. The Andrew Carnegie Foundation provided the funding for this public library building, which was constructed in 1914 of Chehalis brick. The foundation recommended certain design features common to their public library style, including main entry columns and terra-cotta work on the exterior. This building served as Olympia's public library until 1978.

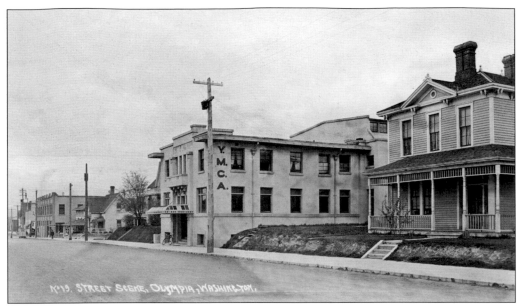

The top view, taken from a *c.* 1915 RPPC, shows the original YMCA building. It is still in use today at 510 Franklin Street. The image below features the Olympia Women's Club. Built in 1906 at 1002 South Washington Street, it was one of the oldest women-only clubs on the West Coast. First a center for the domestic arts, it later branched out to discussions of local, national, political, and social questions. Its civic and philanthropic projects included the operation of the Olympia library from 1896 until 1907. Abbie Howard Hunt Stuart, an active member of the women's suffragette movement in Washington, was founder and first president. She was a strong-minded woman who hosted many visiting suffragettes during the fight of Washington women for the right to vote. Through their efforts, women in Washington held the right to vote from 1883 to 1887, when it was revoked by the territorial supreme court. Women did not regain the right to vote until 1910. (Above courtesy of Paul Longcrier.)

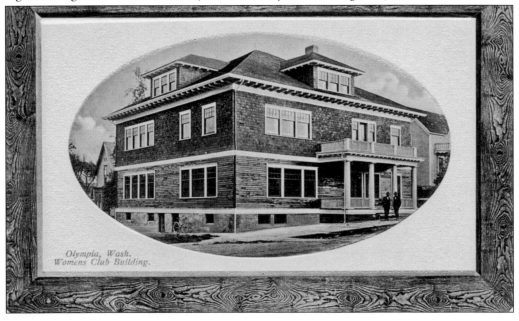

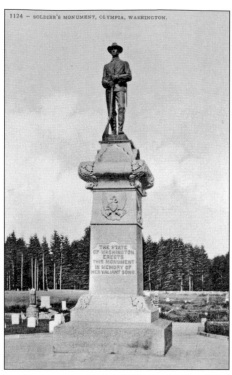

1124 – SOLDIER'S MONUMENT, OLYMPIA, WASHINGTON.

THE STATE
OF WASHINGTON
ERECTS
THIS MONUMENT
IN MEMORY OF
HER VALIANT SONS

The 1901 legislature appropriated $2,500 for this monument to commemorate the valor of the dead U.S. volunteers of the First Washington Regiment who are resting in the Olympia Masonic Cemetery state plot. The 16-foot pedestal is of native granite and surmounted by a bronze figure of a U.S. volunteer in the Philippines service uniform. The structure is nearly 23 feet high. The figure was modeled after a photograph of one of the members of the First Washington Regiment.

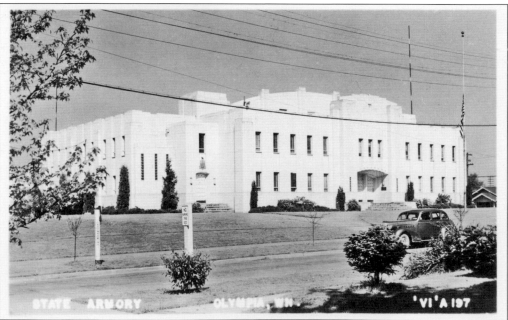

STATE ARMORY OLYMPIA, WN. 'VI'A 197

Located on Eastside Street, between Fifth Avenue and Legion Way, the Washington State National Guard Armory was built in 1938 in the art deco tradition under Works Progress Administration (WPA) financing. As shown in this RPPC, it is a large concrete building and its grounds and associated structures occupy a full city block. In its unaltered state and still used for its original purpose, the armory is notable primarily for various ornamental details that make it a fine example of the governmental buildings constructed at the time.

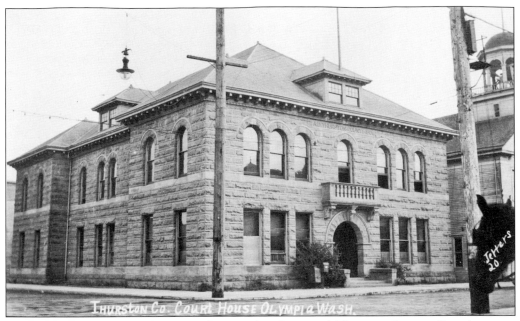

After the state purchased the original turreted and towered Thurston County Courthouse to use as the state capitol, a replacement building was necessary. Charles Patnude, a local Olympia contractor, built this replacement located at the corner of Fourth Avenue and Washington Street. It was razed in 1934. The Columbia Hall Gazebo is visible in the upper right corner of this *c.* 1910 RPPC. (Photograph by Jeffers.)

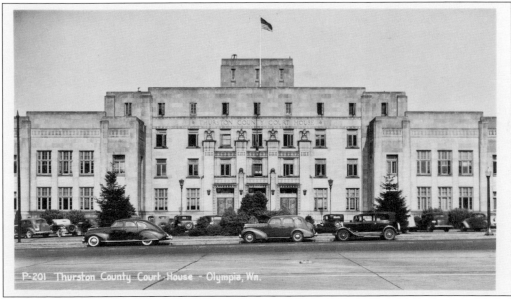

This *c.* 1938 postcard shows the Thurston County Courthouse. The top floor, stepped back with smaller windows, served as the county jail. The message on the back was penned by G. Milliron: "once held the famous 'Doc' Berry (kidnapper) who resides at Walla Walla now. When Berry was residing here at town, I delivered papers 2 his home, then I got a better route and by gosh I delivered papers at the jail (4th floor) 2 him every day. About 3 dozen HAMS here in town all of which I know well."

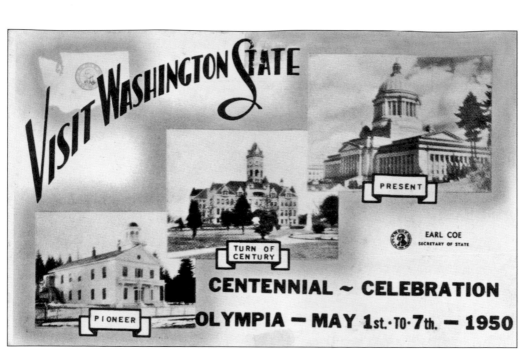

This postcard was issued by the Washington Secretary of State's office to celebrate Olympia's centennial in 1950 and also to promote Washington state tourism. The three state capitol buildings are illustrated. Olympia's weeklong celebration was held May 1–7 in 1950.

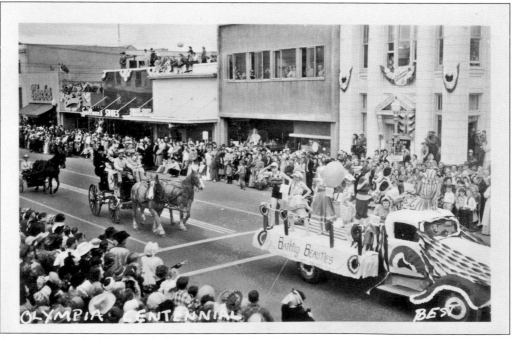

Spectators watched this parade from the sidewalks, from storefront windows, and from rooftops. The Olympia Centennial parade was held during the first week in May 1950. In this RPPC view, swimsuit-clad models, portraying beauties from 1890, pose for onlookers from the back of a truck. A horse-drawn stagecoach follows. This scene was taken from the corner of Capitol Way and Fifth Avenue. (Photograph by Best Camera Studio, Olympia.)

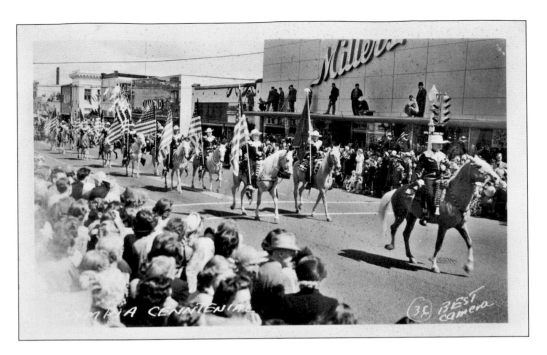

Here are two more vintage RPPC scenes from Olympia's 1950 centennial parade. These views were taken from near the intersection of Capitol Way and Legion Way. The top view shows what was possibly the mounted sheriff's posse, many carrying U.S. flags. Note the men in the upper background. Some are capturing the moment on film from their ringside seats, a perch atop the storefront roof siding at Miller's department store. The lower view features a float carrying the queen and her court.

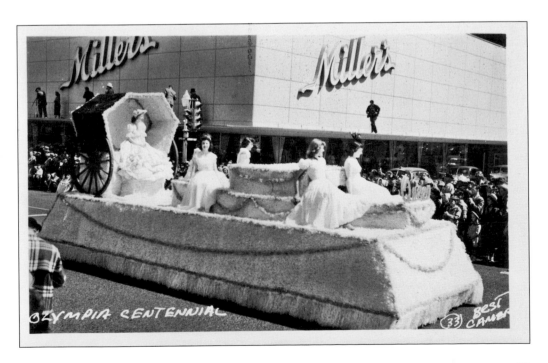

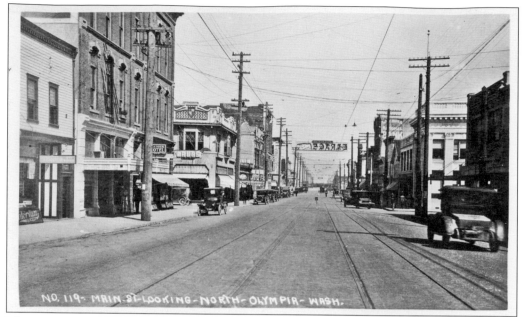

This RPPC shows a section of Olympia's Main Street, today called Capitol Way, around 1920. The brick building at left is the Rainier Hotel. The large building midway down the street on the right is the Olympia National Bank building. The Funk and Volland building is visible and was built in 1909 by George Funk and his sister, Addie Volland.

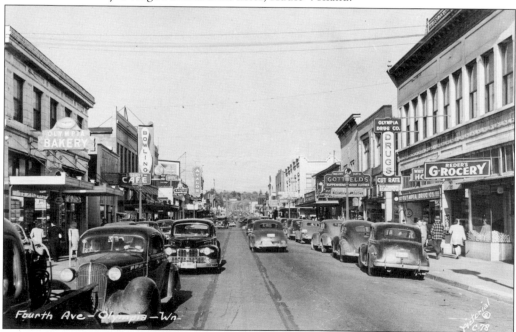

A vibrant Fourth Avenue street view of premium parking spots is featured on this *c.* 1945 RPPC. Over a decade before the first shopping centers were developed, Olympia's business district was focused in the downtown area. Signs for the Olympia Bakery, the Liberty Café, a bowling alley, and C. R. Harris Paints decorate the left side of this street. Signs on the right include Reeder's Grocery, Olympia Drug Company, Gottfeld's Clothing, and Karl's Shoes.

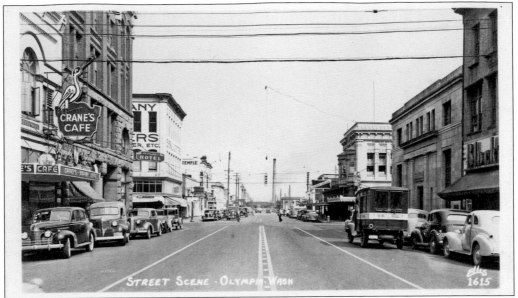

Here are two *c.* 1945 views of Capitol Way, Olympia's main street, with vantage points about two blocks apart and both looking to the north. The top view is near the Fourth Avenue intersection and shows the eye-catching Crane's Café storefront at the far left. The venerable Kneeland Hotel is next door. A U.S. mail truck is parked at right, near the front entrance of the Capitol National Bank, and a bit farther down the street is the Puget Sound Power and Light Office. The Kneeland Hotel would not survive the major earthquake that struck the area in 1949. The lower view looks north from two blocks farther south at the Legion Way intersection with Capitol Way. The Stuart Hotel is the large building at the right and houses the Vincent Candy Store and an ice cream parlor (where shakes are 15¢) on the main street level. Signs on the left side of the street can be seen for Nueffer's jewelry store, Rexall Drug, Ideal Café, and farther down the street are the Crane Café and the Kneeland Hotel.

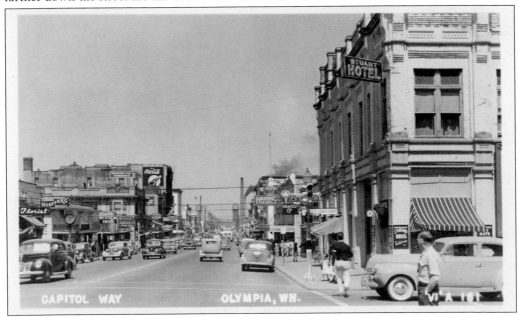

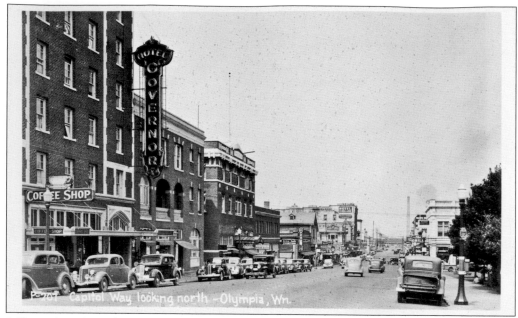

Still another view along Capitol Way looking north is shown here. This image is taken from near the Seventh Avenue intersection. The Hotel Governor is prominent at left. Next door is the Mitchell Hotel and then the Elks Lodge. One block north on the left, at the corner of the Legion Way intersection, is a sign for the Olympia JC Penney's store when it was in its infancy. Three blocks north, the Kneeland Hotel is visible near the center of this *c.* 1945 RPPC. Sylvester Park is at the far right, and the Stuart Hotel is visible one block down on the right.

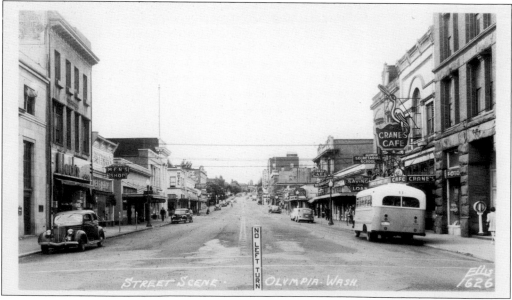

Finally, a view looking to the south along Capitol Way, near the Fourth Avenue intersection, is shown in this *c.* 1945 RPPC. Perhaps the photographer took this shot on a Sunday, as street traffic is noticeably quiet. The Capitol National Bank is at the extreme left with Block's Department Store next door. The Kneeland Hotel is at the extreme right with the Crane Café next door. The Hotel Governor is the large building in the background at right.

Three

SCHOOL DAYS

As with most new settlements in the west, one of the first buildings erected after settlers put a roof over their own heads was a schoolhouse, which often doubled as a public meeting place.

The first schoolhouses were made of split or sawed lumber, little more than log cabins. Attendance in those early days was slim, the benches and work desks less than comfortable. Wintertime was schooltime, and the lessons consisted of the typical reading, writing, and arithmetic. The messages written on the backs of old postcards suggest that a goodly amount of spelling was thrown into the mix.

Whether by class or some other happenstance, a number of small private schools appeared in the Olympia region. Many were boarding schools housing just a small number of children. The Providence Academy for girls opened and was run by the Catholic Sisters of Charity.

Olympia Collegiate Institute (1875–1890), was a boarding school for the whole northwest, later becoming the Pacific Lutheran Evangelical Seminary and eventually an Olympia public school. The Puget Sound Wesleyan institute, first a young ladies seminary, became the first Central School. It was cut in two, moved to the corner of Union Avenue and Adams Street, and put back together. There was no point in wasting a good building. Children of pioneers trooped there including Harry Crosby, the father of Bing Crosby.

The good times rolled in the 1890s, and the town experienced a population and building boom. The legislators, realizing the need for a more centralized system of equal education, passed laws establishing state support for local school districts. From that time on, the school district, working with the state, has sought to ensure a good system of education for all children.

Citizens voted and approved bonds for construction of three new elementary schools— Washington and Lincoln, in 1891, and Garfield in 1893. These were imposing, towered brick structures with eight rooms each. Presidential names reflected well on a state capitol, as was fitting. All three schools were replaced in the 1920s with new mission-style buildings. The William Winlock Miller High School, built in 1907, was replaced early on also.

In the decade leading up to 1910, the public school enrollment doubled, and children then attended school for eight months rather than six. Today there are namesake schools for each of the original four.

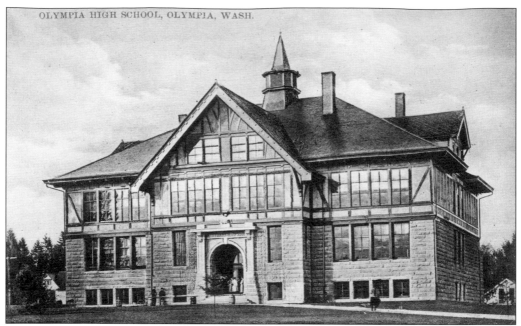

William Winlock Miller High School, also known as Olympia High School, was built in 1907. Constructed of Tenino sandstone, the school was located near the capitol grounds and later sold to the state when the capitol grounds expanded. The school's namesake, William Miller, came to Olympia in 1853. After rising in the military ranks and serving as commissary general staff officer to Isaac Stevens, Miller was named superintendent of Indian affairs. His family donated land for the first high school, and each succeeding high school has been named in his honor. The building burned in 1918. The sophomore class at the high school was assembled at the front entrance for the image below. It numbered about 50 students when this RPPC image was taken in 1913. Note the attire—how well dressed the classmates appear.

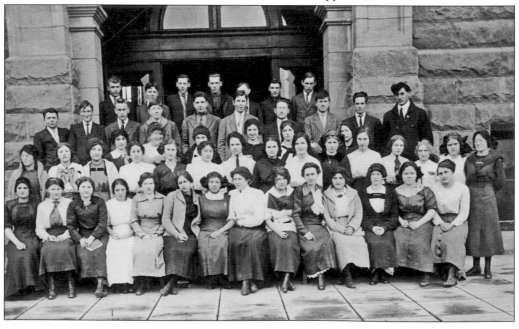

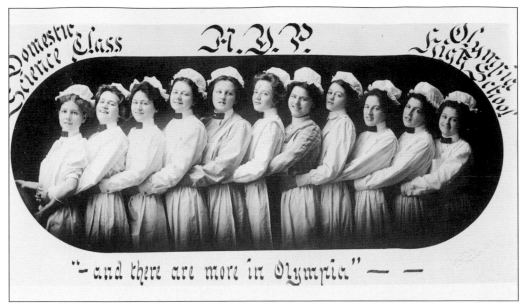

These 11 young ladies, students at Olympia High School, present a pretty picture on this *c.* 1909 RPPC. The writer of this postcard, Agnes, is presumably one of the girls pictured. She notes in her message on the back that she and her classmates gave out these cards as souvenirs when they attended a domestic science class demonstration at the Alaska Yukon Pacific Exposition held in Seattle in 1909.

The second William Winlock Miller High School is shown in this *c.* 1920 RPPC shortly after it was built in 1919. New library books and furniture were required as the previous namesake school had burned. Designed by Tacoma architects Heath and Gove and by Joseph Wohleb of Olympia, it was located across the street from the capitol campus. When the capitol campus expanded in 1960, this school was torn down.

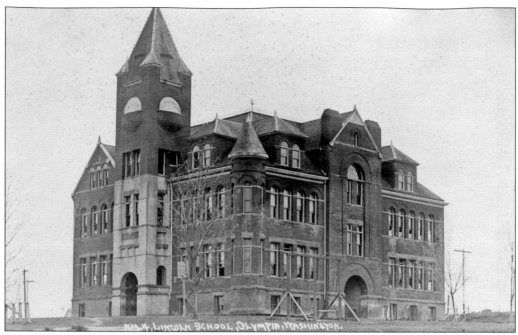

The Lincoln School was built in 1891 at the southeast corner of Thirteenth Avenue and Cherry Street. It had a difficult structural history. A severe storm occurred while it was being constructed, almost toppling part of the large brick building. The tower collapsed shortly after completion and was rebuilt. In later years, it had to be propped up again but the school stood long enough for many children to pass through its doors before being torn down in the 1920s.

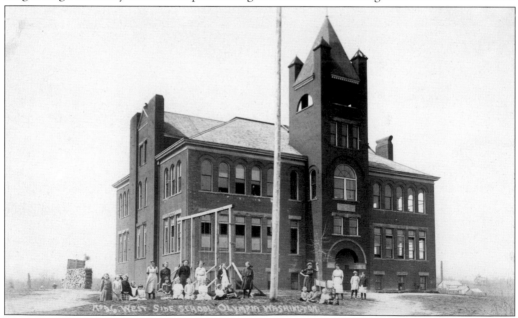

One of three schools built in Olympia during the 1890s, the West Side School served as an elementary school. It was also known as the Garfield School. This image from a *c.* 1910 RPPC shows some of the students and teachers posed near the swings in front of the school. (Courtesy of Paul Longcrier.)

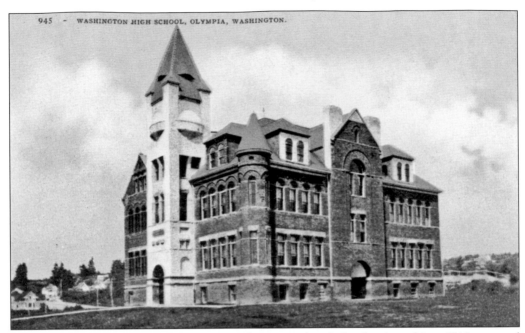

Washington High School had been in use for over a decade by the time this *c.* 1910 postcard image was made. The growing Olympia area population in the 1890s had warranted the building of three new schools, including this one. Each school was quite similar in design and the cost of each was $25,000. All three schools were brick structures with imposing towers, and each had eight classrooms. In the 1920s, all of them were replaced.

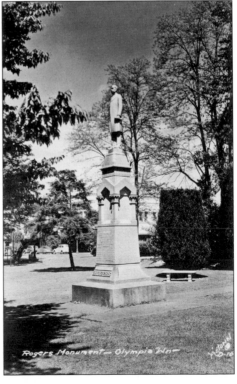

This statue commemorates Gov. John Rogers, who instituted the "Barefoot School Boy Law" equalizing funding statewide for all children's education. Contributions for the memorial were raised by the state's schoolchildren. Governor Roger's favorite motto was, "I would make it impossible for the covetous and avaricious to utterly impoverish the poor. The rich can take care of themselves." This image of the statue as it stands in Sylvester Park was taken from a *c.* 1940 RPPC.

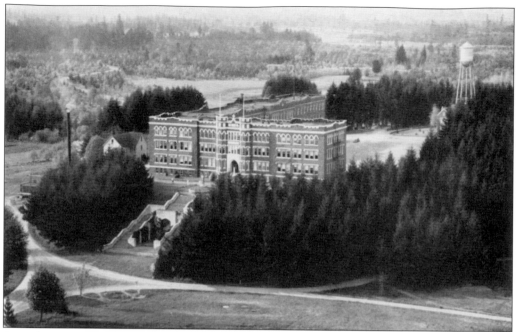

As early as 1893, the Benedictine Catholic Order had sought a location in Western Washington for a monastery and men's college. The order chose a site in Woodland, the early name for Lacey, which adjoins Olympia to the north. In 1895, an imposing wood frame structure was built to serve as the first school. Today's brick buildings were begun in 1913 and completed in the 1920s. "Old Main," the prominent building on campus, is a fine example of collegiate Gothic architecture. These two aerial-view postcards—the top image looking from the northeast and the bottom image from the southwest—show "Old Main" and the rest of the St. Martin's campus around 1945. At this time, St. Martin's included both a high school and a college.

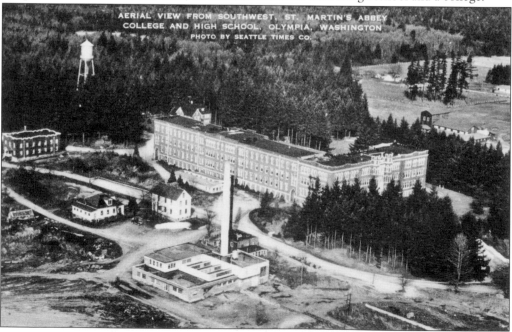

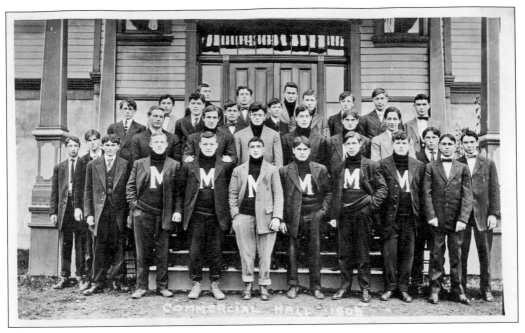

The upper RPPC view shows the college boys posed in front of St. Martin's commercial hall (one of the school's first main wooden structures) in 1909. The young men in letter sweaters were members of the football team. The *c.* 1909 RPPC image below shows the students assembled for their school picture on St. Martin's Day. A boy standing in the center of the second row holds a St. Martin's pennant, and just behind him, an older student flaunts his SMC sweater. Note that many of the boys in the front rows are quite young in age. First established as a boarding school, St. Martin's had students that ranged in age from elementary on up. (Below courtesy of Paul Longcrier.)

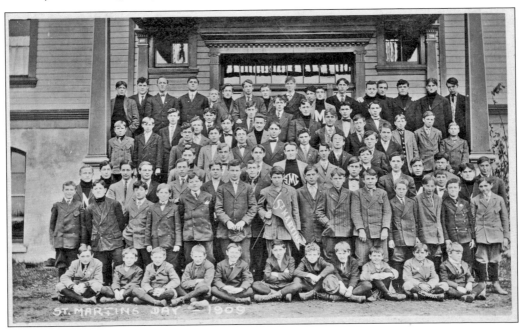

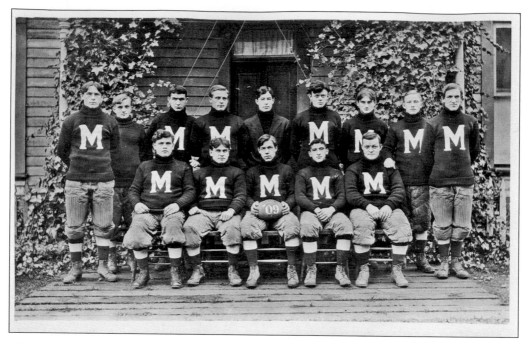

The top RPPC pictures the St. Martin's college football team in 1909. Thirteen players are shown, which may have included most of the team members. It was common for players to cover both offense and defense in those days. Eleven players from the team are pictured in the RPPC below. The caption says, "After the Game," and these lads have definitely been in a game. Their uniforms are soiled and their hair is disheveled, but judging from their expressions, one would guess that the St. Martin's team pulled out a victory that day. If you look closely, you can match up players below with their "pregame" portraits in the upper image.

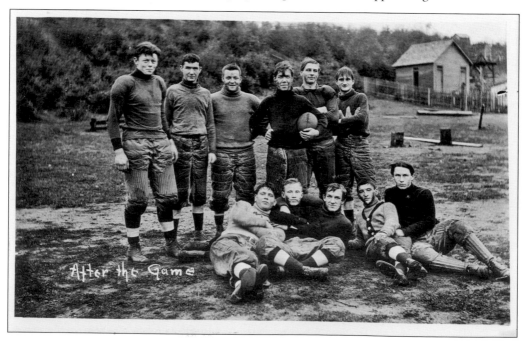

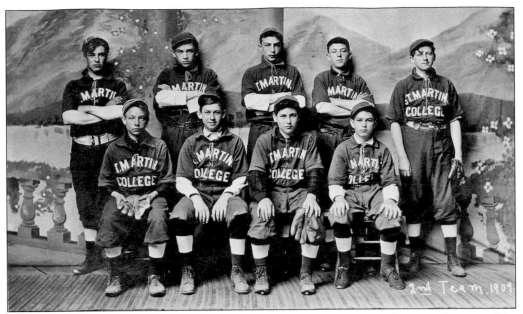

The nine baseball players pictured in this vintage RPPC made up the second team of St. Martin's College in 1909. The players have been identified on the back of the card as, from left to right, (first row) Harvey (left field), Baillaryson (third base), LaRoque (right field), Carson (catcher); (second row) McKenzie (pitcher), McLean (first base), Sanderson (shortstop), Page (second base), and Steward (center field).

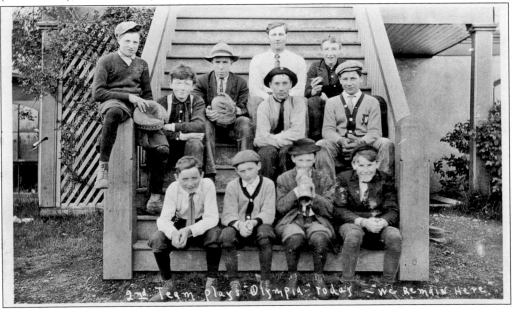

This team is most likely from St Martin's College. The boys pose with the message "2nd Team plays 'Olympia' Today—We Remain Here." Were these boys the first team players? The South Sound region flourished as a haven for "America's Favorite Pastime." Local towns, as well as lumber mills and other businesses, had teams that were recorded on postcards. Like the group photographs taken today, RPPC images of teams from yesteryear were distributed to players and their families. Today many of these items are scarce and choice collectible items.

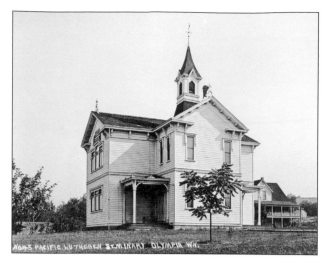

Established in 1907 by the Lutheran Church, the Pacific Lutheran Seminary was a private educational institution. Its purpose was to provide a Christian education overall and to educate young men for the gospel ministry. The property purchased for the school on East Bay Drive and Olympia Avenue was previously known as the People's University, and prior to that, as the Olympia Collegiate Institute. The dormitory, built in 1890, is visible to the right of the main school building, as shown in this *c.* 1910 RPPC image.

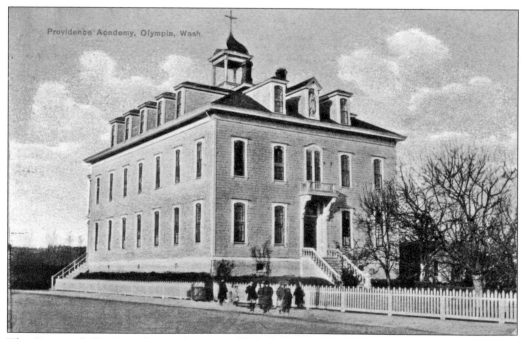

The Sisters of Charity of Providence established the Providence Academy, located at Ninth Avenue and Columbia Street in downtown Olympia, in 1883. Construction was supervised by Mother Joseph of the Sisters of Providence. In 1889, the school began taking in a few boys and between the years 1910 and 1920, the school blended with the St. Michael School. It operated as a boarding and day school until 1926, when the building was purchased by St. Michael's Church and the schools were closed.

Four

OUT ABOUT TOWN

For those staying close to home with a day to spare, Priest Point Park was the early destination. A short launch trip up the bay put you into the wilderness. The park has survived as one of the nation's prettiest natural parks. It exists as a mute rebuttal to Chief Joseph's prophecy that with the white man, "there [would] be no place dedicated to solitude." During Prohibition, jailed drunks were a strain on the police budget, and the city sought relief by sending them out to the park woodpile to work off their fines. If you worked, you were fed three meals a day. If not, you had to get by on one.

Like any other little town anywhere in the country during the years leading into the 1940s, nearby highway construction forever changed the face and character of all places it touched. Olympia was no different. The arrival of Highway 99 brought its share of pleasures and problems. Motels and restaurants sprang up to meet the traveler's needs. The ticky-tacky tourist gimmick that was intended to thrill the gullible, while "picking their pockets," was born. The public had a few extra dollars to spare, and the motto on the old postcards was, "See America First." Today most of the old highway sections around Olympia have been paved over or modified, like old sections of U.S. Highway 99 buried under I-5.

Nationwide, the airline industry took off, and Olympia missed the moment by failing to lure a major line into the overhead skies and land, that is. The bus business was born. Buses had expanded routes that took you out of town toward the horizon of your choice. Few ponder these things we take for granted, but in the years leading up to the 1950s, all this was new. It was an exciting time after the depression and World War II, when Americans could get "out about town." The country was heading into the "fabulous fifties."

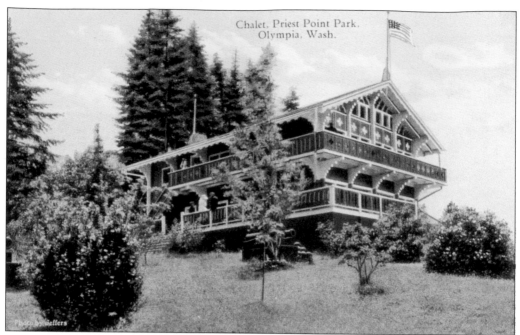

Chalet, Priest Point Park.
Olympia, Wash.

Originally the site of an early Oblate Catholic mission, the 240 acres comprising Priest Point Park was purchased in 1905 by the City of Olympia. Certainly one of Washington's earliest examples of a real estate development project gone awry, the land had reverted to the courts for delinquent taxes owed. The city fathers seized upon the moment, and future generations have been the benefactors of their decision. Local citizens formed work parties for clearing trails, installing landscaping, and even holding clambakes. Leopold Schmidt donated the structure that became the Priest Point Park Pavilion, and the work crews reerected it on the site. It had been built for Schmidt and used as the Olympia Brewery building at the 1904 Lewis and Clark Exposition in Portland, Oregon.

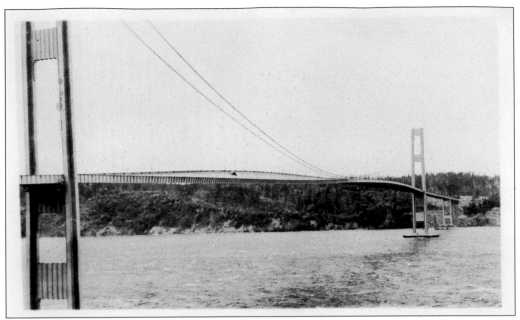

"Galloping Gertie" spanning the Tacoma Narrows is shown here heaving, swaying, and ready to topple. This bridge is shown in her death throes on Nov. 7, 1940, as captured in this vintage RPPC image. The literal downfall of the bridge led to a portion of her girder remains being used to support the Olympia Supply Building, located at 625 Columbia Street. The building's founder, Earl Bean, was a man who wasted little. (Courtesy of Paul Longcrier.)

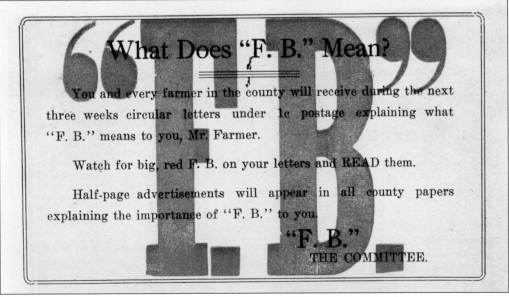

Postmarked from Olympia and sent to John Bannse of Bucoda in 1920, this postcard was sent to call awareness to a newly formed program. Today's farm bureau (FB) acts as a rural chamber of commerce, aiming to "make the business of farming more profitable and the community a better place to live." As a national organization, it pools buying power for services such as insurance and most county-level bureaus sponsor safety classes around such issues as machinery and pesticides. Some may sponsor social events as well.

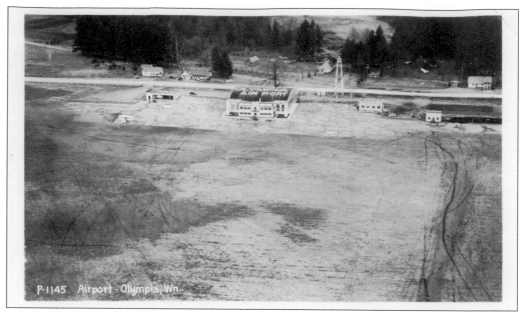

The city entered the aviation age when, in 1928, a bond issue was passed to purchase property for an airport. Grand plans for a large-scale airport never came to fruition, and the major air carriers excluded Olympia from their main routes. This *c.* 1948 RPPC image provides an overview of the Olympia Airport structures in place at the time. Peter Schmidt was instrumental in bringing the airport to Olympia. (Courtesy of Paul Longcrier.)

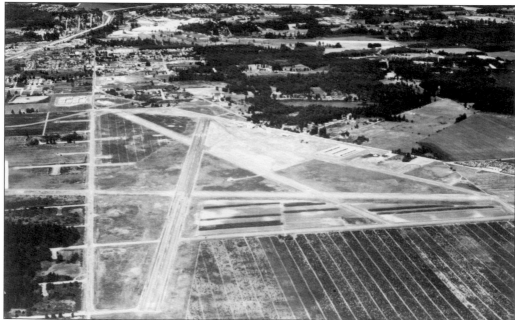

This *c.* 1963 RPPC image shows an aerial overview of the airport and landing strip. Text printed on the card's back reads, "Developing as Western Washington's finest general aviation field, adjoining the Thurston Airdustrial Center, a planned light industrial park fronting Freeway I-5. Full aircraft and fuel servicing by Capital Airways and Vagabound Aviation—visit Washington's capital city by air."

This *c.* 1930s RPPC shows locals Boots and Buddy Zeller—winners this day at the Schneider's Prairie Walkathon event. The walkathon was held indoors, with participants walking round and round the enclosure. Prizewinners went home with hard-to-come-by money. This Quonset hut–style building, the "Tropics Ballroom," was about 5 miles southwest of Olympia. Rumored to be a rather rowdy place at times, the consumption of alcohol and high spirits in hard times led to flared tempers. (Courtesy of Paul Longcrier.)

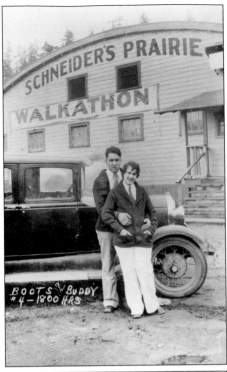

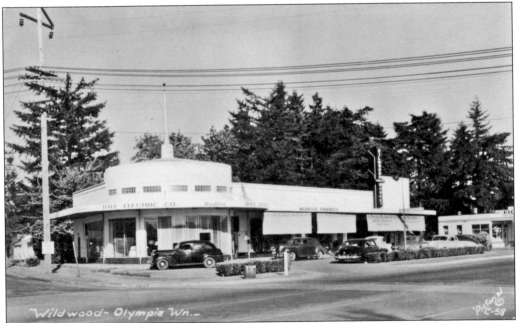

A precursor to today's modern mall, the Wildwood Shopping Center was built to hold a unified collection of stores. The center was built in 1938, in the then fashionable art moderne style for businessman G. C. Valley. Its eye-catching exterior reflected the classic appearance of the day with its rounded lines, thick glass block windows, and smooth stucco walls. Shown here in a *c.* 1940 RPPC view, this building remains at 2822 Capital Boulevard Southeast. (Courtesy of Paul Longcrier.)

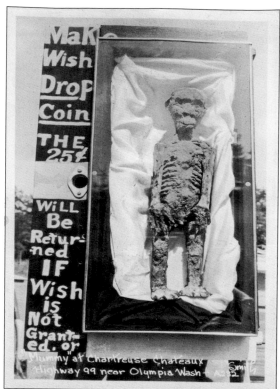

At left is Olympia's own roadside tourist attraction, "Make a wish, drop coin—The 25¢ will be returned if wish is not granted." The sign fails to say how long one was to wait before knowing whether or not the wish would come true. At least the "mummy" was available for immediate viewing at the Chartreuse Chateaux on Highway 99 near Olympia. (Courtesy of Paul Longcrier.)

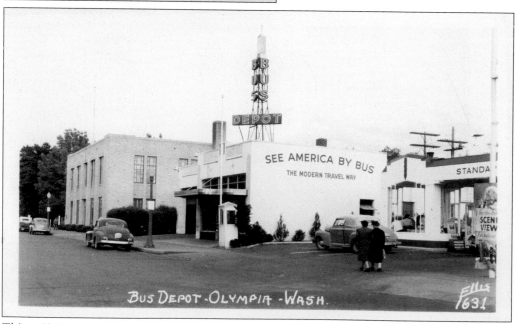

This c. 1945 RPPC image shows the Greyhound Bus Depot building, still standing at Capitol Way and Eighth Avenue. Built in 1936, this structure is one of the few art moderne structures in Olympia. With its bold geometric trim and curved chrome awning, it was designed to reflect "the modern travel way." It later was home to the North Coast Transportation Company. A Standard service station is visible to the right. (Courtesy of Paul Longcrier.)

The caption on this RPPC, postmarked 1909, reads, "Where peace was declared by the Indians near Sargent's home in Rochester, Washington." According to local legend, this tree was referred to as "The Gun Treaty Tree." The image was snapped by local Oakville photographer S. H. Price. (Courtesy of Paul Longcrier.)

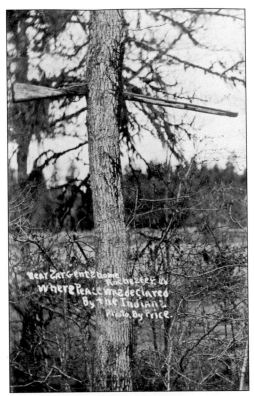

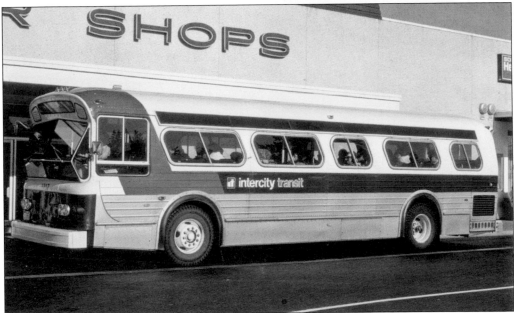

The chrome postcard view shows Intercity Transit No. 1217. This 35-foot intercity transit bus was photographed in Olympia in 1980, and its image was made into a postcard. Today the Intercity Transit provides bus transportation services in the Olympia, Lacey, Tumwater, and Yelm areas. In 2009, the company won recognition as the best medium-sized transit system in the United States.

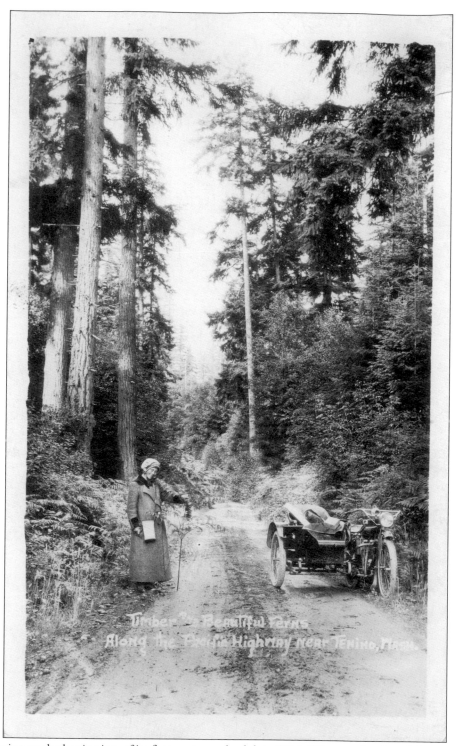

Olympia saw the beginning of its first motorcycle club in 1913. Women also found them to be a snazzy way to get around, as shown in this *c.* 1930 RPPC image captioned, "Timber and beautiful ferns along the Pacific Highway near Tenino, Washington." (Courtesy of Paul Longcrier.)

Five

BUSINESS AND ADVERTISING

Olympia's population in 1940 was a mere 15,000. The stores required to serve the needs of the citizenry were initially located in the area business center in downtown and around the Capital Campus complex.

As the state capital, the town's history is also tied closely to the history of its hotels and motels. Much of its drawing power has always been centered on this status. Visitors, particularly legislators, staff, and lobbyists, have tied the ability of Olympia to retain its title as the capital of Washington with having adequate and quality housing available when needed. It was a city with many deluxe accommodations available throughout the years in the form of nice hotels. All this was to change in the mid-1940s, as more middle-class families became car owners. Vacation traveling became the norm. The Olympia area, like many other communities, saw a growing food and lodging business.

It was not until after World War II that the terms "motel court" and "motel" came into widespread usage. Higher land and construction costs after the war physically transformed the tourist court. Separate lodging units were changed to individual units, integrated under one continuous roofline with recessed parking. By 1954, the covered-parking layout disappeared as the motorist seemed content to park his car by his room.

Tourist hotels had been a hallmark of the Highway 99 corridor before the construction of the I-5 freeway through Olympia in 1958. As each new hotel and motel was constructed, it attempted to offer "the best accommodations in town." A whole new class of business had arrived with the automobile.

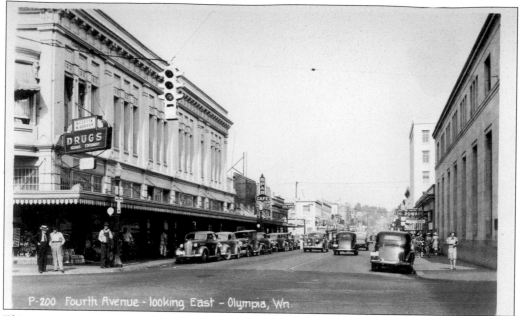

This RPPC from the 1940s shows the location of the Spar Café and Bar. A Spar Café sign is visible midway down the left side of the street at its location on Fourth Avenue. It is overshadowed by the Chambers building, and on the corner, the Gillette and Guffey Drugs also sold Kodaks and stationery. (Courtesy of Richard Smith.)

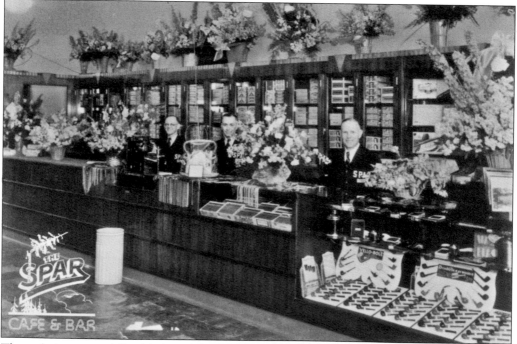

The early image used for this Spar Advertising postcard shows a well-stocked counter of tobacco products to serve the smokers of the day. Note the large selection of pipes on display—lower right—with cigars and cartons of cigarettes in good supply. Potted bouquets of flowers added to the decor, and these three smiling uniformed gentlemen were ready and waiting to serve customers.

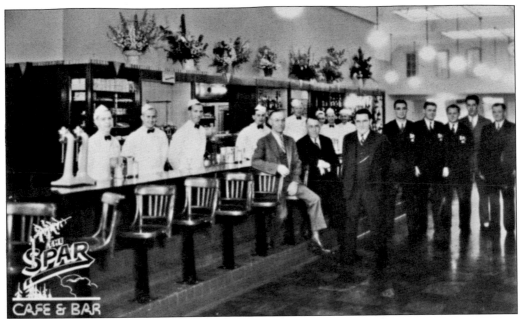

The two Spar advertising postcards pictured on this page show interior views of the Spar Café and Bar as it was about 1940. Long a favorite haunt in downtown Olympia, this legendary business opened in 1935 and was locally operated by the McWain family. Often termed "South Sound's Second Home," it kept those with idle time entertained by accepting wages on sporting events as well as providing a gathering spot for gentlemen of the day. A classic café counter and back bar, shown in the top view, provides the setting for a group portrait. Behind the counter are cooks and waiters in white uniforms and caps. Note the billiard and pool-table room getting heavy use as shown in the image below.

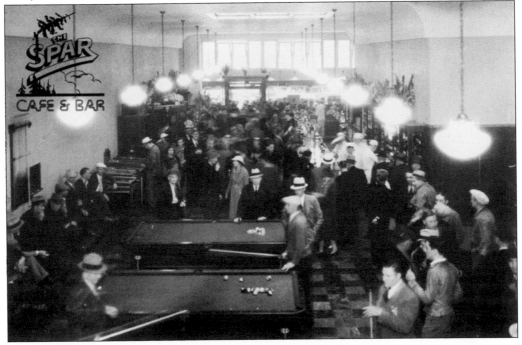

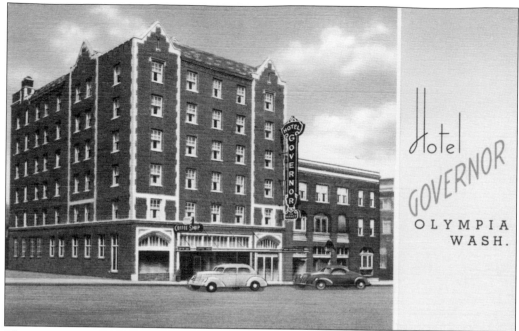

The *c.* 1940 linen advertising postcard shows the Hotel Governor in its heyday. In the late 1920s, a renovation of the Mitchell Hotel and new construction resulted in this seven-story hotel. It towered over its counterparts, including the remaining portion of the Mitchell Hotel next door. Note the towers along the front and side rooftop of the Hotel Governor. These towers would be badly damaged as a result of the 1949 earthquake, forcing major renovation. The *c.* 1950 RPPC image below provides a post-quake look of the hotel sans towers. Located on Capitol Way, at the intersection with Seventh Avenue, Hotel Governor advertised good food and service "on Highway 99." (Below courtesy of Paul Longcrier.)

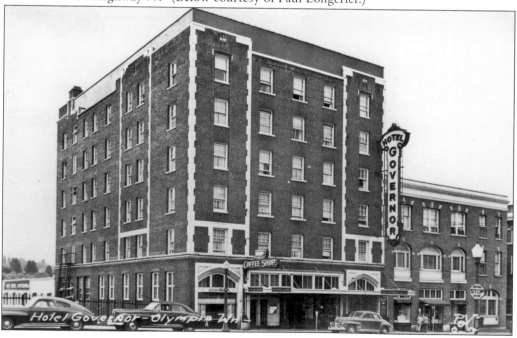

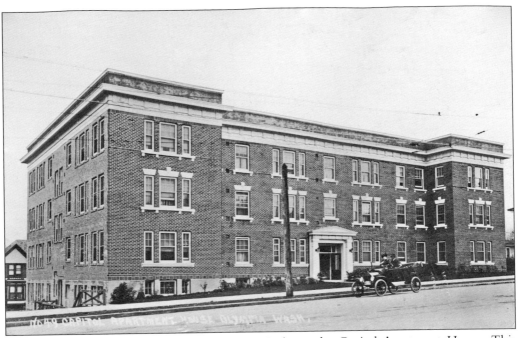

Postmarked from Olympia in 1916, this RPPC shows the Capitol Apartment House. This building was originally constructed to provide luxurious, prestigious rental units. It finally fell to the wrecking ball in the 1960s during the capitol campus expansion project.

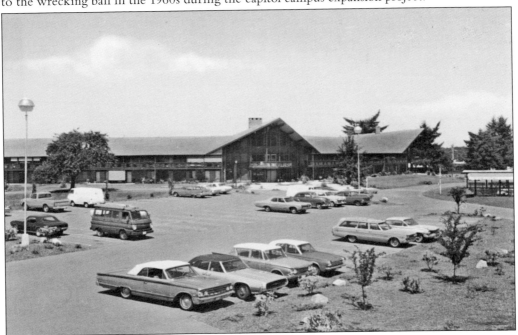

Panorama City opened in 1963 in Lacey, which borders Olympia to the north. One of the first retirement communities in the Northwest, it accommodates adults and senior residents, offering a total life-care environment. It has proven to be a very successful venture and is still in operation today. Advertising printed on the back of this c. 1970 postcard includes "Beautiful swept-wing Chalet and the parking area near the Administration Building."

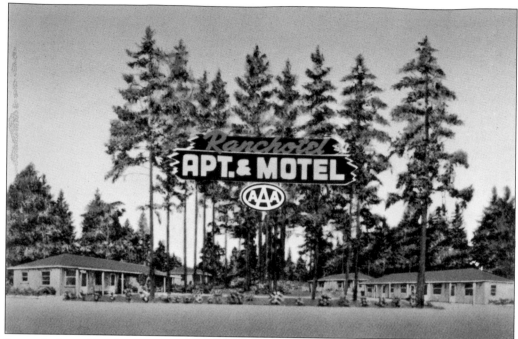

Located about 7 miles north of Olympia, about halfway between that city and Fort Lewis on Highway 99, the Ranchotel was described as an "Apartment Court and Motel" on this *c.* 1955 chrome advertising postcard. Affiliated with the American Automobile Association, the Ranchotel presented itself as a cozy place to stay in the great, wooded outdoors. Text printed on the back of this card states, "Deluxe Apartments Completely Furnished." The Ranchotel mailing address was in Olympia and it still exists today under the same name.

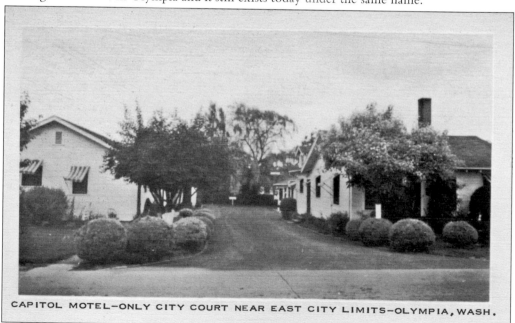

CAPITOL MOTEL—ONLY CITY COURT NEAR EAST CITY LIMITS—OLYMPIA, WASH.

This *c.* 1950 postcard serves as an advertisement for the Capitol Motel, which billed itself as the only city court near the east city limits of Olympia.

80

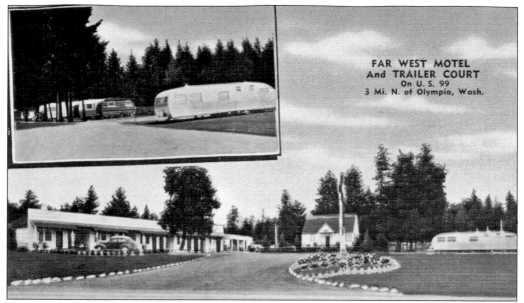

Catering to motorists with and without trailers, the Far West Motel and Trailer Court was located on U.S. Highway 99, about 3 miles north of Olympia. Information printed on the back of this *c.* 1946 linen advertising postcard includes "7 Modern Units, single and double—kitchens—showers—refrigerators—Shady trailer park with sewer—modern restrooms—showers—automatic laundry room—bottled propane gas."

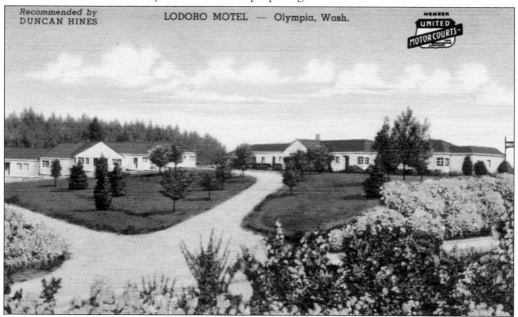

One of Olympia's earliest motels was the Lodoro, shown on this 1946 linen advertising postcard. Built from 1939 to 1940 and expanded in 1945, the Lodoro had strong credentials. It was a member of the United Motor Courts and was recommended by Duncan Hines. In 1940, the Duncan Hines guide "Lodging for a Night" included only one listing for the state of Washington, the Lodoro Motel in Olympia. Mr. and Mrs. L. S. Twiet were owners and managers at the time.

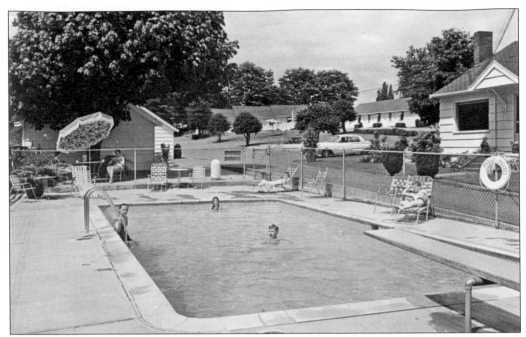

It was a good day for a swim at the Holly Motel, located at 2816 Martin Way East, 1 mile northeast of Olympia on U.S. Highway 99. Advertising text on the back of this *c.* 1964 postcard includes, "35 new, first class units. Beautyrest beds, room phones, free T.V., ice & coffee. Heated pool, putting green, shuffleboard. Mr. and Mrs. Rodney Moreland, Owners—Mgrs." The motel's telephone number, FL 6-4471, used the old Fleetwood prefix.

The Golden Gavel Motor Hotel was a popular downtown motel, located adjacent to the state capitol and the town's business section at 909 Capitol Way South. The motel is pictured in this postcard view shortly after it was built in 1958. Its proximity to the capitol campus made it a popular place for legislators and lobbyists to stay. Its name was synonymous with the gaveling of the legislature to order.

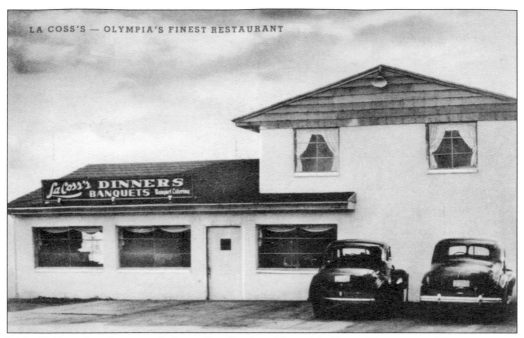

This 1940s printed postcard shows La Coss's—Olympia's Finest Restaurant. The restaurant offered banquet catering. (Courtesy of Paul Longcrier.)

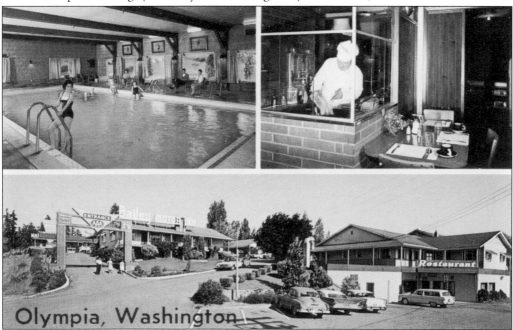

Located at 3333 Martin Way East, the Bailey Motel began with 15 units in 1946. By 1956, the business had been renamed Bailey Motor Inn, expanded to 42 units, and included a coffee shop and dining room. Later additions featured a large, heated indoor pool as shown in this c. 1960s chrome postcard. In the 1980s, it was the only such establishment to offer live gambling in the form of a card room where poker was played. Down the hall, live music was played in the cocktail lounge.

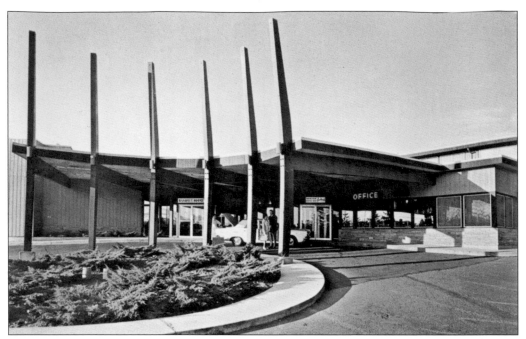

This postcard shows the futuristic front entrance to the Tyee Motor Inn. Tragedy struck the business in 1970 when fire destroyed all but 30 units. It broke out in the kitchen area and the structure burned rapidly, lighting up the sky for miles and sending guests—including lobbyists and legislators—running out into the night. Thanks to heroic and speedy action by several individuals, there were no casualties. Quickly rebuilt, it continued to operate for almost 30 years.

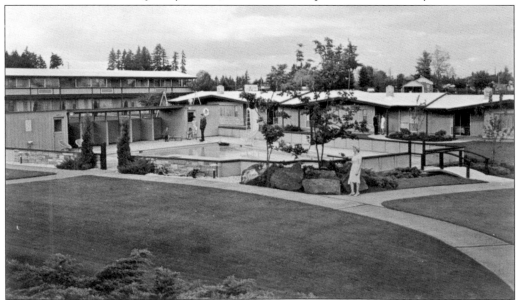

Long an Olympia landmark, the Tyee Motor Inn began in 1958 as a modest restaurant-motel business. It quickly expanded into a luxury motel and by 1961, it had become famous as a popular spot for Olympia's legislators. The outdoor pool is showcased in this advertising postcard surrounded by motel units. A shopping center complex now covers the spot where the Tyee stood near the intersection of Trosper Road and Littlerock Road Southwest.

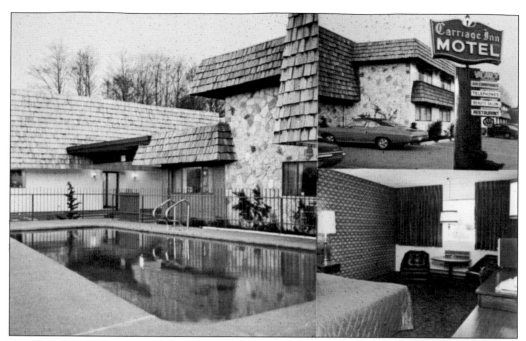

The Carriage Inn Motel was located off the Plum Street exit near the Olympia city center. Built in 1965, it had an adjacent restaurant featuring a sawtooth roof design. The front entrance, a room interior, and a view of the outdoor swimming pool are shown in this *c.* 1970 postcard view. Advertising text on the back of the card billed the Carriage Inn as "Olympia, Washington's Finest." The hotel featured air-conditioning and touch-tone phones.

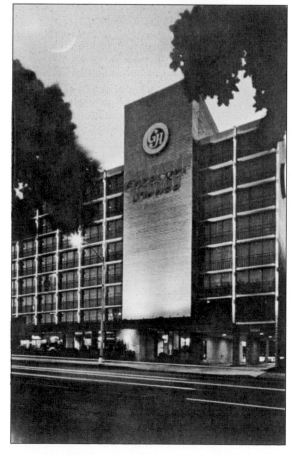

Located five blocks from the capitol, at 621 Capitol Way in downtown Olympia, the new Governor House was opened in 1972 replacing the old Mitchell Hotel and Governor Hotel. This new hotel features a modern articulated frame building with an eight-floor tower. Information on the back of the card states, "126 luxurious rooms and suites, pool, 24 hour restaurant. Dine and dance to nightly entertainment. Banquet and meeting facilities."

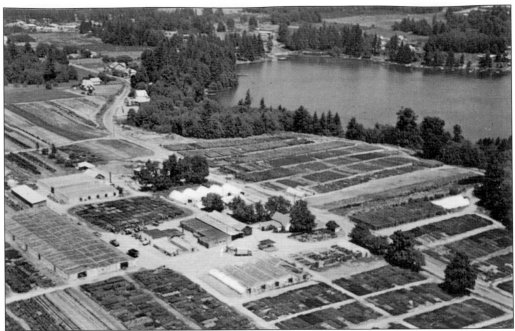

An aerial view of Briggs Nursery is shown in this *c.* 1967 postcard image. Located one and a half miles southeast of Olympia, the business consisted of "100 acres of ornamental nursery stock in containers and B. & B.," as denoted by text printed on the back of the card. Its address was listed as 4202 Henderson Boulevard. Briggs Nursery was a wholesale grower dating back to 1912.

Located at the Port of Olympia, the newly built radio station KGY is "One of America's most uniquely situated broadcasting stations," according to the caption on the back of this card. Granted an official license in 1922, KGY was one of the nation's first radio stations. Fr. Sebastian Ruth, a St. Martin's monk, was the founder. The station carried operas and live performances. In addition, Ruth conducted a radio-telegraph school on the air.

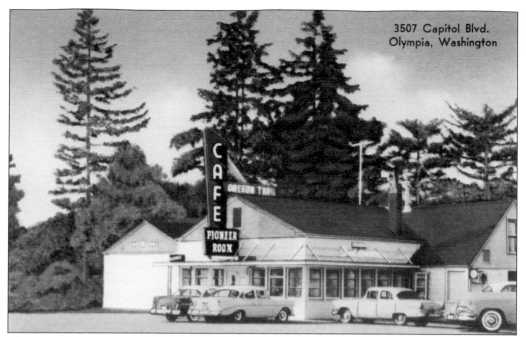

The Oregon Trail Inn was historically located at the end of the Old Oregon Trail at 3507 Capitol Boulevard. It was near the Olympia Brewery. This view, taken from a *c.* 1955 linen postcard, shows cars parked in front of the café, which featured its Pioneer Room for dining and dancing. Advertising printed on the back of the card promotes "Our Specialty—Steaks, Seafood, Chuckwagon, Dining—Dancing—Cocktails—Banquets."

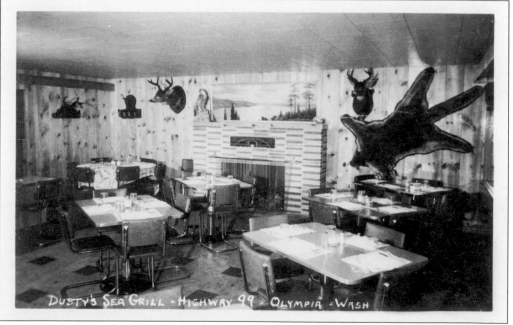

The interior of Dusty's Sea Grill is showcased in this *c.* 1955 RPPC view. The walls feature a wild game animal décor, somewhat in contrast to the surroundings that might be conjured up when hearing the restaurant's aquatic name. Dusty's was located on Highway 99, outside of Olympia.

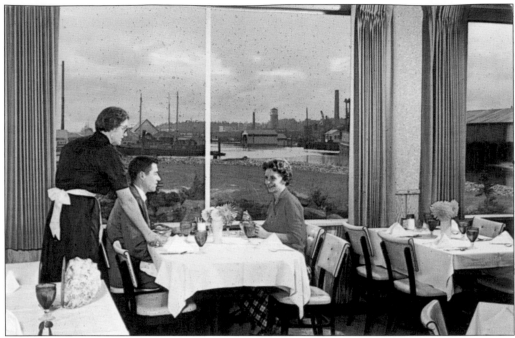

The Olympia Oyster House has been a prominent seafood restaurant in Puget Sound since the early 1900s. The top view, accenting a dining couple's window view of the harbor at dusk, is taken from a *c.* 1956 postcard. Located at 320 West Fourth Avenue, the Oyster House is famous for its various preparations "of the worlds' [*sic*] smallest and most delicious oyster, grown only in the southernmost inlets of Puget Sound near Olympia," as noted on the back of the card. The lower view shows an exterior view of the Oyster House front entrance and dates to about 1964. Menu specialties described on the reverse include "Olympia Oyster Hangtown Fry" and the "Oyster Omelet."

Six

THE CAPITOL
THE SEAT OF POWER

The early residents of Olympia took to heart their "right" to be the capital city, first of Washington Territory and then of Washington State. They found it a "right" that had to be repeatedly contended for as through the years, other cities made sometimes sneaky attempts to steal the honor. They sought the prestige and power that accompanies the title. When quickly examined, what would Olympia be today, if it had not possessed that title? The title brought influence, clout, name recognition and the stabilizing force of steady revenue.

The leaders of the gangs, including the governors, legislators, and lobbyists, constitute the players in a series of performances that have played consecutively through the years. The mention of the bit players, in the form of all those necessary to cater to the stars' needs, must not be overlooked. Olympia has been a stage filled with ever-changing drama. Laws needed to be carefully crafted, controls installed to continually address the people's changing needs. Laws are needed to keep civility in check. The business of Washington State is honestly, big business.

Buildings to house the functions of this coveted crown had to be built, rebuilt, and built again. Edmund Sylvester, when platting the original city, had deeded a beautiful tract of land to hold the future capitol site. His vision did not see the eventual sprawl that future generations would need to carry out this function. City landmarks and neighborhoods disappeared under the growth that came. It must be said that the performers, making up the lines as they went, brought to creation a capitol campus of which the citizens of the state can truly be proud.

Today, here in this seat of power, the hopes and fears of all those little people back home are still laid bare, for better or worse.

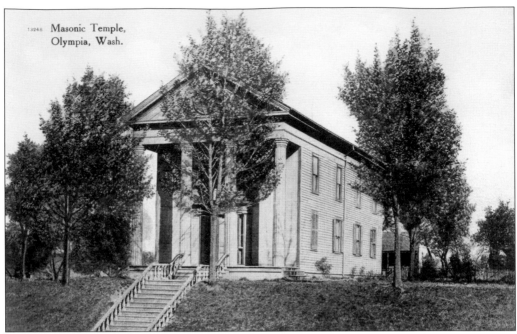

Masonic Temple, Olympia, Wash.

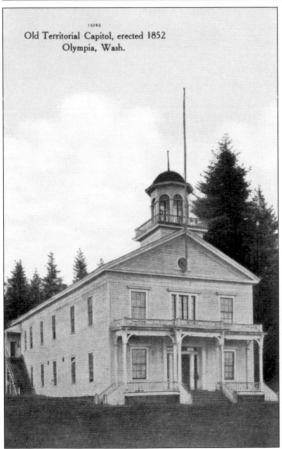

Old Territorial Capitol, erected 1852
Olympia, Wash.

The first Masonic temple organized in Washington Territory stood at the corner of Eighth Avenue and Capitol Way on land donated by Edmund Sylvester. It was used for many civic purposes. As the only suitable structure in town, it was designated as the site of the territorial legislature during the Indian uprising of 1855–1856. Designed in a classical style, it had a temple front with four columns across the façade. This building was razed in 1911.

The title of capital has been fought for and jealously guarded throughout Olympia's history. In 1855, this old wood-framed building served as the first capitol building when Olympia was established as the permanent capital of Washington Territory. The stairway visible at the rear of the building provided access to a later addition. Although that right had been awarded in 1855, other towns continued to press for the title, seeking the economic benefits and prestige that accompanied the honor.

Marion E. Hay was elected in 1909 as Washington state's lieutenant governor. As fate would have it, the elected governor Samuel Cosgrove died after just one day in office. Hay, a card-carrying member of the Anti-Saloon League supported the ASL's efforts to put the city saloons out of business. Many "blue laws" were passed during his administration. Also of great social impact, legislation securing a woman's right to vote was passed during his term. This was due to the efforts of the women's suffragette movement.

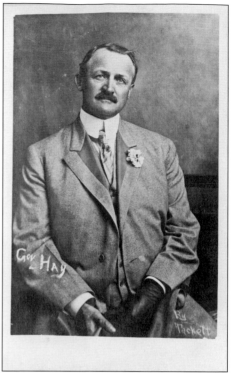

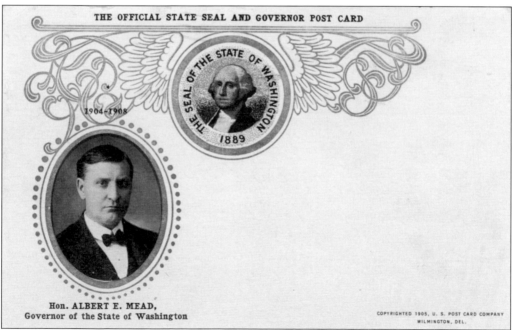

THE OFFICIAL STATE SEAL AND GOVERNOR POST CARD

1904-1908

THE SEAL OF THE STATE OF WASHINGTON

1889

Hon. ALBERT E. MEAD,
Governor of the State of Washington

COPYRIGHTED 1905, U. S. POST CARD COMPANY
WILMINGTON, DEL.

Elected in 1904, Gov. Albert E. Mead's term included the passage of much reform legislation. One measure prohibited public employees from accepting gifts from those doing business with the state. Hunting license fees were enacted, and seasons were established for birds and fisheries. Mead is best known not for his reform efforts, but rather for being instrumental in thwarting an effort to move the state capital from Olympia to Tacoma. He served one term.

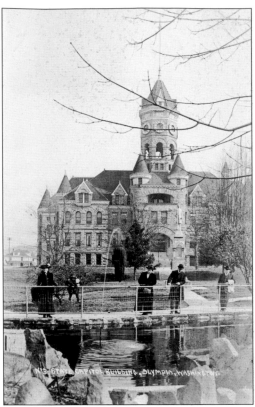

This *c.* 1910 RPPC shows passersby pausing to enjoy the goldfish pond in Sylvester Park. Across the street in the background stands the then state capitol building. The park was plotted originally in 1850 as the town square by the town's founder, Edmund Sylvester. The park's usage has evolved through the decades. It began as a grazing spot, then served as a site for a stockade during the Indian Wars, was used as a city jail afterwards, and is now a gathering spot for celebrations and band concerts.

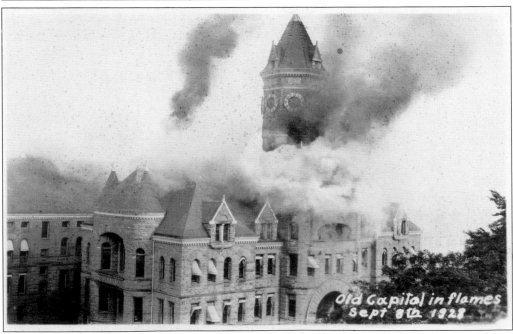

This vintage RPPC image shows the octagonal clock towers being destroyed by fire on September 8, 1928. The beauty of the building was further marred when the 1949 earthquake damaged most of the turreted towers beyond repair.

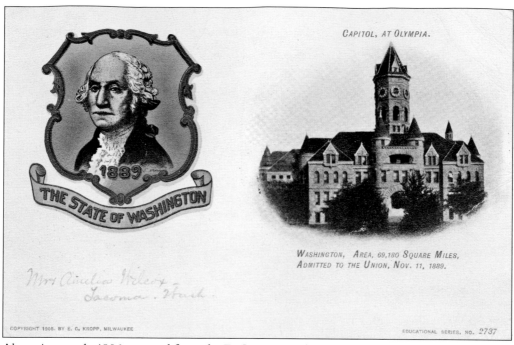

CAPITOL, AT OLYMPIA.

WASHINGTON, AREA, 69,180 SQUARE MILES,
ADMITTED TO THE UNION, NOV. 11, 1889.

1889

THE STATE OF WASHINGTON

COPYRIGHT 1905, BY E. C. KROPP, MILWAUKEE

EDUCATIONAL SERIES, NO. 2737

Above is an early 1906 postcard from the E. C. Kropp Educational Series depicting the towered Washington State Capitol building along with George Washington. The lower RPPC shows the Governor's Mansion that was built in 1908. It is the oldest building still standing in the capitol complex and was specifically built to house visiting dignitaries on their way to the Alaska Yukon Pacific Exposition in Seattle in 1909. This is amazing as it was built in a hurry and never intended to last. Designed by Tacoma architects Russell and Babcock, it contained one of the best collections of Americana antique furniture in the United States after completion. The mansion was renovated and enlarged in 1974.

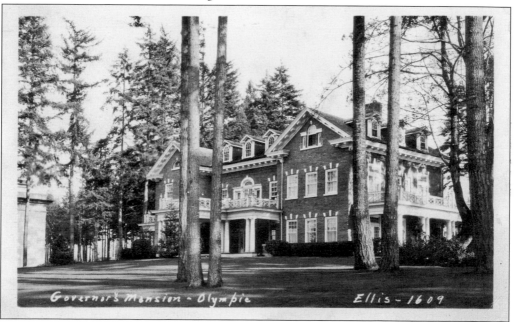

Governor's Mansion - Olympia Ellis - 1609

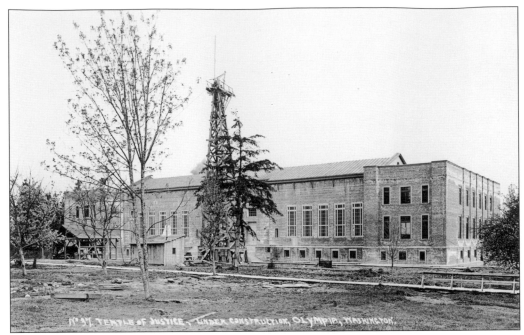

This *c.* 1912 RPPC image shows the Temple of Justice building under construction. The Temple of Justice was the first of the capitol campus group to be completed. It was completed in stages due to difficulties in financing, with the interior not completed until 1920. In its unfinished state, it served as the site of Governor Lister's inaugural ball in 1913. Its design and style were reflected in the buildings that followed.

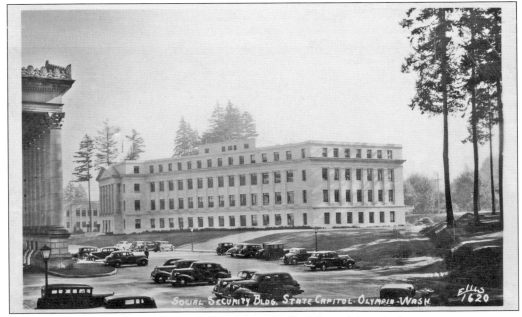

Officially known as the Public Land Social Security Building, this capitol campus structure was built in 1937. Z. Vanessa Helder, one of the leading WPA artists of her day, produced two mural maps for this building. They were installed on the east and west walls, depicting the eastern and western portions of the state. Today there is no record of their fate.

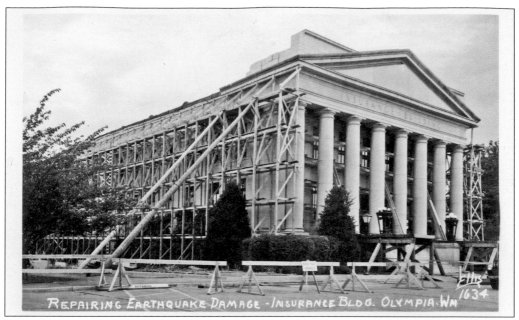

Damage repair was underway on the Insurance Building, shown here shortly after the summer of 1949 earthquake struck the Olympia area. This building, completed in 1920, was the second of the Wilder and White designs constructed. It was designed with a roofline built of sandstone so as not to detract from the nearby legislative building.

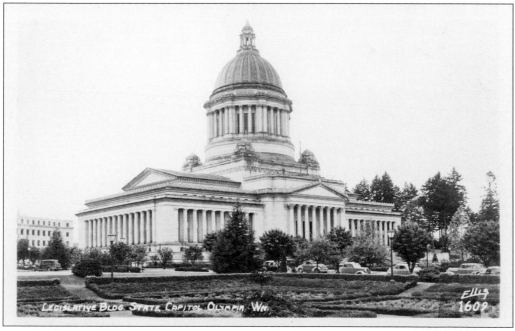

Designed by Wilder and White of New York City and constructed between 1922 and 1928, the Washington State Legislative Building in Olympia has been described as the "climax" of the American Renaissance of state capitol construction. It has the fourth-tallest masonry dome in the world, rising 287 feet high. The legislative building holds the House of Representatives, the senate, and the offices of the governor, lieutenant governor, secretary of state, and treasurer.

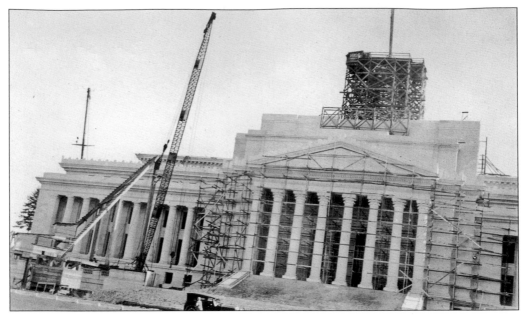

This photograph, taken in 1924, shows the legislative building taking shape on the capitol campus grounds. Construction of the dome had just begun. It shows the front entrance framed with scaffolding. The entire construction period of this building lasted from 1922 to 1928. (Courtesy of Paul Longcrier.)

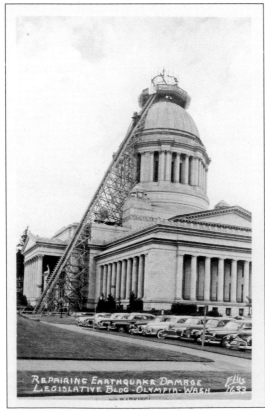

The legislative building has withstood three major earthquakes, thanks in large part to the excellent structural design by Wilder and White and the superior craftsmanship of the original builders. The first earthquake in 1949 damaged the cupola of the legislative building's dome so badly it had to be completely replaced. This RPPC shows the scaffolding used as this repair was taking place. The dome holds the title of the tallest self-supporting masonry dome in the United States. (Courtesy of Paul Longcrier.)

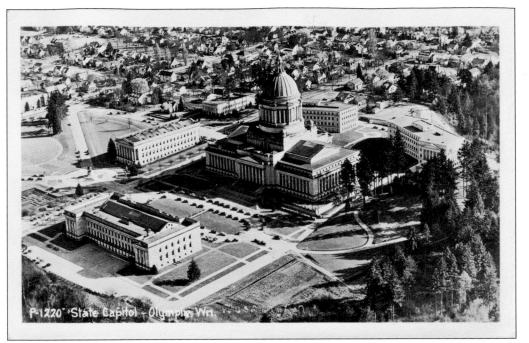

In 1911, Wilder and White won the state's design contract competition, which required contestants to provide a long-range site plan for a group of buildings. The state had become convinced by its recent experience with the former courthouse that the spatial demands of the government could not reasonably be satisfied by any one structure. Therefore, the seat of government today consists of a capitol campus with several buildings located on the site.

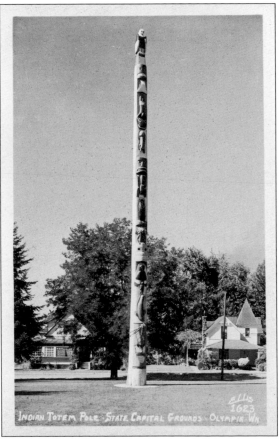

Carved from a cedar log by Chief William Shelton of the Snohomish tribe, the 71-foot story pole is designed in the Salish Indian tradition and features many of the symbols of Northwest Indian legends. Often incorrectly referred to as a totem pole, a story pole put its emphasis on teaching children community responsibility and cultural attitudes through the depiction of these same animal characters. It features 21 beautifully carved figures, each teaching a certain life lesson.

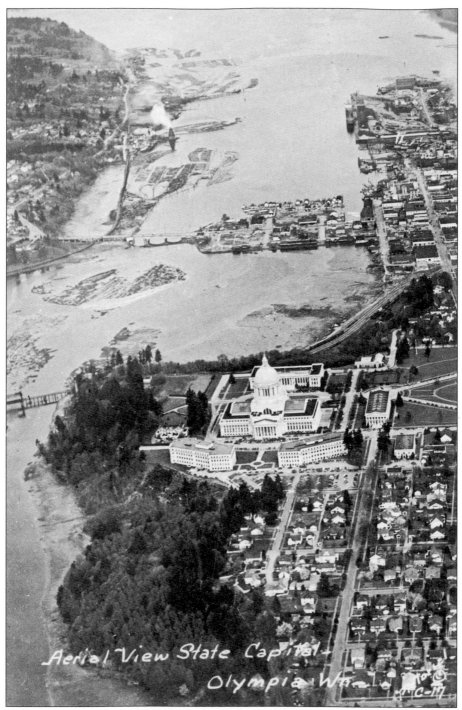

Aerial View State Capital
Olympia Wn

This *c.* 1940 RPPC aerial view shows an Olympia much different from that of today. Here the 1921 Fourth Avenue Bridge is in place. There is no Fifth Avenue Bridge, which now forms the dam at the end of now Capitol Lake. The Northern Pacific Railroad facilities ring the west side of the Deschutes River marshy tidal basin before it was tamed. Smoke billows from the plywood plant up on West Bay.

Seven

TUMWATER AND
THE BREWERY

Tumwater was first settled in 1845 by Michael T. Simmons. Upon his arrival along the Deschutes River, he found an area referred to as "Tum Chuck," meaning "throbbing or noisy water." The name referenced the waterfalls located near the river estuary. Archaeological digs and carbon dating have shown the presence of human habitation at this site dating back nearly 3,000 years. American settlement at the site was relatively peaceful other than the brief period of the Indian Wars from 1855 to 1856. The first settlers called the town New Market, but the name did not stick. Tumwater it would be, and the name serves as a reminder of those who once lived along these Southern Puget Sound shores. Subtle reminders also exist in place names and objects seen, such as totem poles.

Simmons saw the waterfalls as a potential source of waterpower for industry and mills. He was soon to erect a gristmill, which drew farmers to the site to have their wheat milled. Roads were built and bridges were put in to cross the waterway from Tumwater to Olympia. Leopoldt Schmidt, after having the local artesian water tested, claimed it to be ideal for the brewing of beer. The Olympia Brewery was born and proved to be a major presence in the community. The Northern Pacific Railroad put in a spur line to service the site. The City of Olympia put in a streetcar line powered by electricity generated at the power plant that was built along the waterfalls.

The Deschutes River was tamed by a dam constructed in Olympia to create Capitol Lake. This ended any possibility of navigation from Puget Sound to the mouth of the Deschutes, though the navigation had always been risky at best, due to shallow waters and tidal flows.

Old Tumwater finally ceased to exist in 1958 when the state constructed the Interstate 5 freeway, physically cutting the city in half. This seemed to open the minds of the locals who found it to be an open doorway. It was a gate to a new future for the once slumbering little community.

This *c.* 1910 printed postcard is captioned, "On the Trail to 'It's the Water,' near Olympia, Wash." and shows a path through the woods near the Olympia Brewery in Tumwater. The slogan "It's the Water" was a familiar advertising slogan during the years of the brewery's operation.

On the Trail to "IT'S THE WATER," near Olympia, Wash.

The image below on a *c.* 1910 RPPC shows a smiling bunch of brewery workers centered around a wooden keg and raising their glasses of Olympia beer to toast the photographer. (Courtesy of Paul Longcrier.)

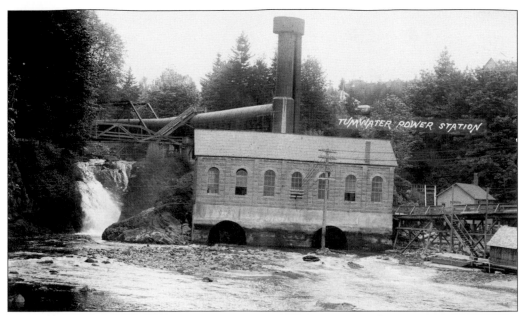

The new Lower Tumwater Falls powerhouse at the mouth of the Deschutes River was operational in 1905. A flume in the form of a large pipe channeled water from the upper fall region and ran downstream along the riverbank. It provided extra waterpower to the 90-plus-foot drop of the three falls combined. This powerhouse provided Olympia and Tumwater with electric light and streetcar service. The upper *c.* 1910 RPPC shows the powerhouse with the pipe flume crossing the river and entering the building where the generator was housed. The two circular openings at the waterline are the discharge tubes. The lower *c.* 1915 printed card shows a close-up view of the tube crossing the falls to connect with the powerhouse. The base of this second powerhouse remains today and is currently being used as the observation platform just below the rushing cascade of the lower falls.

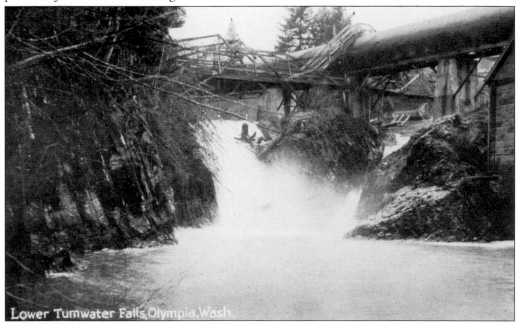

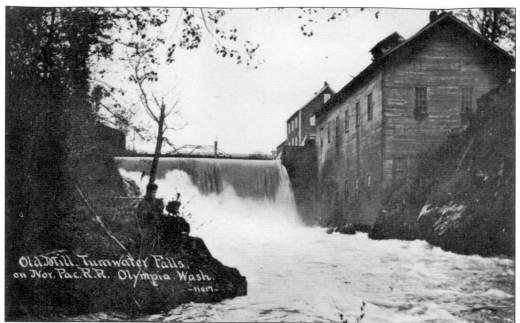

George Gelbach came to the Washington Territory in 1870 and established a flouring mill in a prominent place along the middle falls of the Deschutes River. It was in use until 1890 when the site was purchased by the Olympia Light and Power Company. The upper 1911 image, captioned "Old Mill, Tumwater Falls on Nor. Pac. R.R. Olympia Wash.," shows the first power plant that the company constructed. It was built in 1883 and was a two-story building. The flour mill is the building visible to the rear in the image. The lower *c.* 1915 RPPC shows the remains of the two buildings after they ceased to be in use when the new Lower Falls powerhouse became operational in 1905. The visible waterfall is the result of a dam that was constructed to create the reservoir for power production.

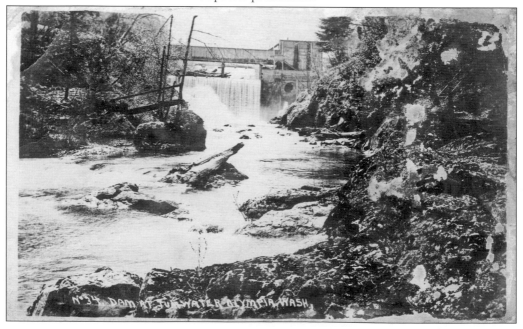

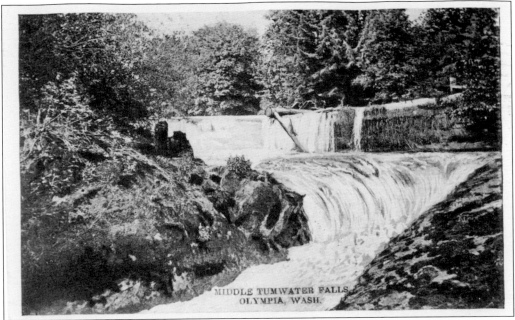

MIDDLE TUMWATER FALLS, OLYMPIA, WASH.

In the early days of Olympia, the Deschutes River was a more turbulent river in its lower reaches than today. Jumbled logs, tossed about in times of high water, littered the waterway and eroded muddy riverbanks that were constantly changing as the waters charged downstream on their way to the bay. The images from that time of the upper and middle falls are not easily recognizable as the falls that confront the onlooker today after the construction of Tumwater Falls Park. The powerhouse dam on the middle falls was removed, and the flow of water and time etched a new face in the riverbed. Today little remains at the site to call a "falls." The upper falls have been channeled and confined to a much narrower width, allowing for the adjacent construction of a fish-hatchery site. These images are printed-postcard views from around 1910.

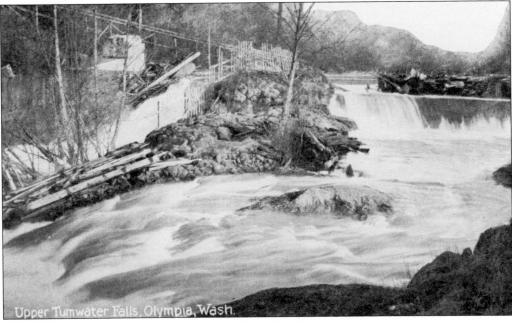

Upper Tumwater Falls, Olympia, Wash.

103

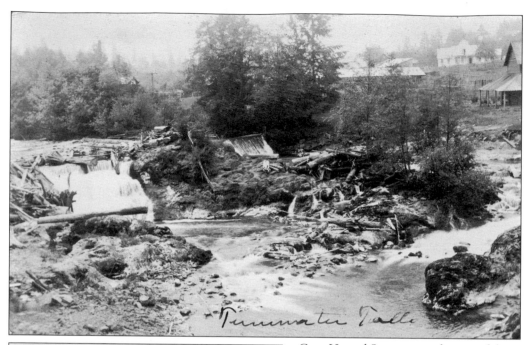

Tumwater Falls

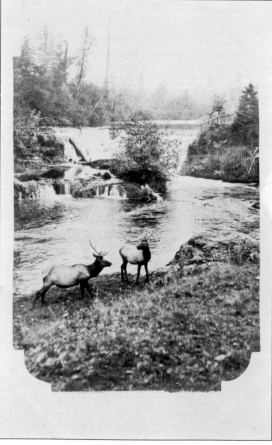

Gen. Hazard Stevens was the son of the first territorial governor, Isaac Stevens. In 1914, he founded "Cloverfields," a dairy outfitted with the most modern equipment. As the president of the Olympia Light and Power Company, he promoted electric usage by boasting of its use in his all-electric barns. The electric streetcar line, operated by the power company, was in-town service with a line running to Tumwater. To entice rider usage, the Elk Farm was established by Stevens near the site of the upper falls. In the above *c.* 1910 RPPC, the piece of roof in the upper right border area shows a portion of the elk barn. In the image at left of the same era, the elk are seen browsing along the rivers edge. (Courtesy of Paul Longcrier.)

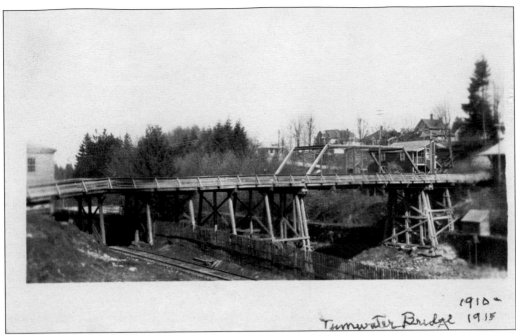

1910-
Tumwater Bridge 1915

Built in 1880, the original Custer Way Bridge was constructed as a single span. Three hundred feet in length, it had a dirt-covered wooden deck that was supported by pilings. It was replaced in 1916. The Olympia-Tenino Railroad Station was located to the left side of the bridge crossing, near where Falls Terrace Restaurant stands today. The above *c.* 1910 RPPC shows the first bridge where it crossed the Deschutes River. The small windowed building visible at the bridge's end on the right side of image is the depot for the Olympia Light and Power Company Electric Interurban streetcar line. The RPPC at right of the same era shows the interurban line track and the waiting platform for riders. The waiting passenger is properly dressed for the day with her hat, gloves, and bustled skirt. Notated on the card's reverse is the following: "1906—On my way to Tumwater Falls." (Courtesy of Paul Longcrier.)

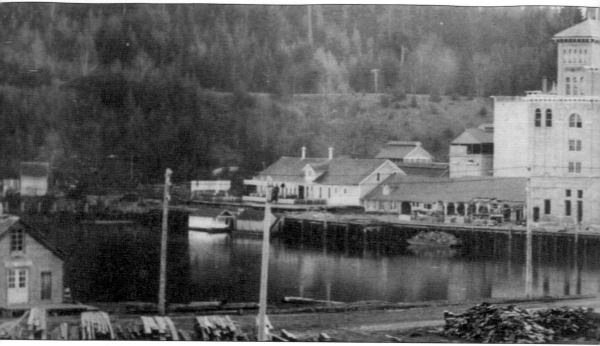

As part of the Olympia Brewery development, they built a wharf and bridge across the Deschutes River mouth. There are historic photographs that show the loading of beer onto small steamboats at the brewery wharf. This had to be done at high tide, as the general area was but a broad mudflat with the river outflow running through it at low tide. The above *c.* 1906

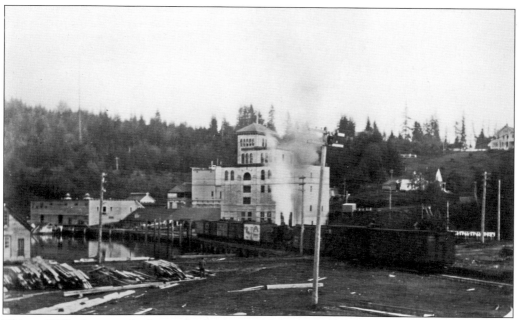

This *c.* 1910 photograph shows the brewery and Long Bridge approach after the Northern Pacific Railroad bridge was constructed and train service begun. (Courtesy of State Library Photograph Collection, Washington State Archives.)

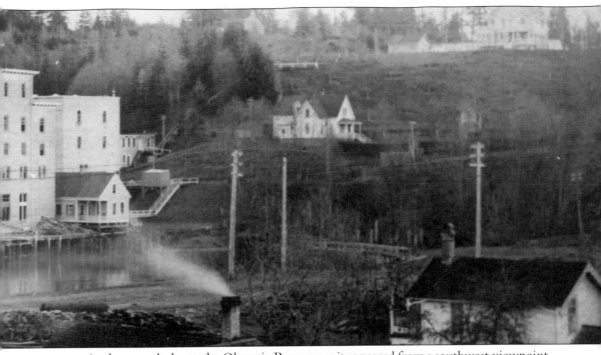

panoramic photograph shows the Olympia Brewery as it appeared from a southwest viewpoint. It shows the docks existing around the building prior to the construction of the railroad bridge. Land area visible in the foreground shows the Tumwater end of the Long Bridge. (Courtesy of State Library Photograph Collection, Washington State Archives.)

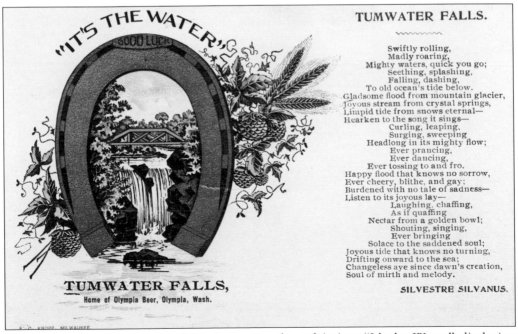

"IT'S THE WATER"

GOOD LUCK

TUMWATER FALLS,
Home of Olympia Beer, Olympia, Wash.

E. C. KROPP, MILWAUKEE.

TUMWATER FALLS.

Swiftly rolling,
Madly roaring,
Mighty waters, quick you go;
Seething, splashing,
Falling, dashing,
To old ocean's tide below.
Gladsome flood from mountain glacier,
Joyous stream from crystal springs,
Limpid tide from snows eternal—
Hearken to the song it sings—
Curling, leaping,
Surging, sweeping
Headlong in its mighty flow;
Ever prancing,
Ever dancing,
Ever tossing to and fro.
Happy flood that knows no sorrow,
Ever cheery, blithe, and gay;
Burdened with no tale of sadness—
Listen to its joyous lay—
Laughing, chaffing,
As if quaffing
Nectar from a golden bowl;
Shouting, singing,
Ever bringing
Solace to the saddened soul;
Joyous tide that knows no turning,
Drifting onward to the sea;
Changeless aye since dawn's creation,
Soul of mirth and melody.

SILVESTRE SILVANUS.

Olympia Brewery printed an advertising postcard proclaiming, "It's the Water," displaying their lucky horseshoe trademark.

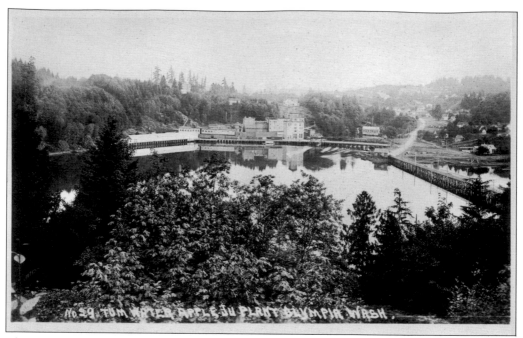

The caption on the RPPC above reads, "Tumwater Apple Ju Plant, Olympia, Wash." Pictured is the road from Tumwater coming down the hill in the center right and connecting to the Long Bridge. Prohibition came to Washington in January 1916, four years before the rest of the nation. Brewing ceased in 1915, allowing brewers one year to deplete their inventory and dismantle their operations. However, the Schmidt family chose to produce a slightly sparkling apple drink called "Appleju." Its slogan was "Drink an Apple," and they later made a heavily sparkling version they referred to as "apple champagne." Unfortunately, nationally all fruit juice production was terminated in 1921 due to a sugar shortage caused by World War I in Europe. The picture below was taken from the Olympia side and shows the Long Bridge with a small covered section, with the brewery to the left at the far end. (Below courtesy of Paul Longcrier.)

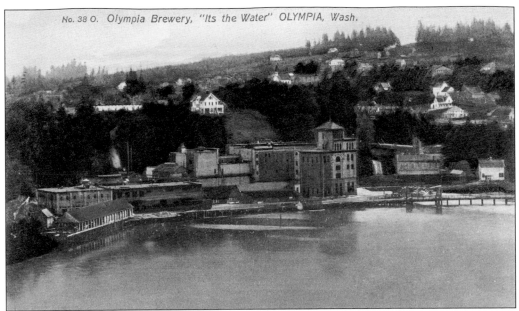

No. 38 O. Olympia Brewery, "Its the Water" OLYMPIA, Wash.

Leopold Schmidt, owner of the Olympia Brewing Company, built a new brewery in 1906. It was located adjacent to his earlier brewery on the Deschutes River waterway below the Tumwater Falls. The original brewery, established in 1896, is visible in the upper 1910 printed-postcard image, discernable as the tall slim structure and adjacent building at the center of the building complex sitting back from the waterfront. The large white house on the hillside above the brewery is the Schmidt home. Below, the reverse of the above advertising postcard is shown. Postmarked 1912, the brewery inquires if the recipient received a sample of Olympia Malt Extract. This card was published by Winstanley and Blankenship, proprietors of the downtown business The Smokehouse.

"Three Meter," so-called by the Leopold Schmidt family, was the home originally built in 1895 concurrent with the construction of the first Olympia Brewery. Schmidt was the founder of the Olympia Brewery. The house is still standing today on the hilltop above Budd Inlet. The brewery was reached by means of a pathway. The above *c.* 1910 printed-postcard view shows the house before a large wing was added in the 1920s. The monument shown in the lower RPPC image is visible today at Tumwater Falls Park in the vicinity of the upper falls. This monument was originally erected nearby in 1916. It commemorates the members of the first permanent American settlement on Puget Sound. It was erected by the children of Leopold Schmidt in accordance with his wishes. (Both courtesy of Paul Longcrier.)

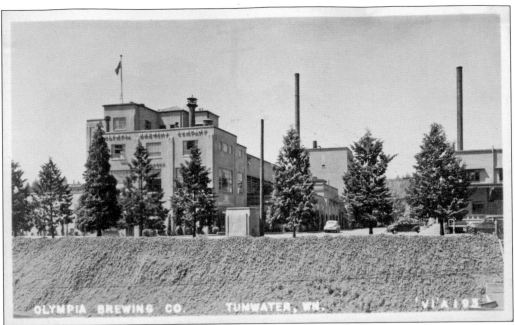

Prohibition ended in 1933, and the Schmidt brothers Peter and Adolph were determined to reestablish the Olympia Beer Label in a new brewery. Economic times in the Depression years made raising the funds difficult. The goal was achieved by selling stock at $1 per share, and a new brewery was constructed on the hilltop. The first beer from the new plant went to market in January 1934. Many pre-Prohibition employees were on staff. At the time, it was considered by the beer industry to be one of the most efficient and modern breweries in production. The above RPPC is *c.* 1940s. The lower RPPC shows the brewery and a large advertisement marking the 50th anniversary of the business.

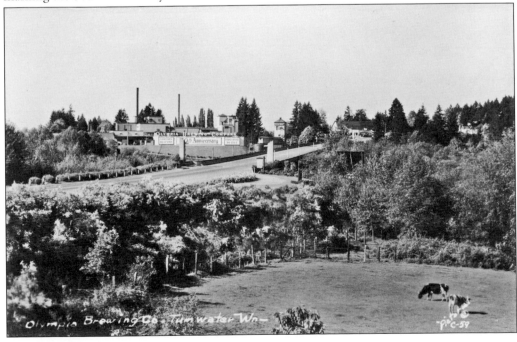

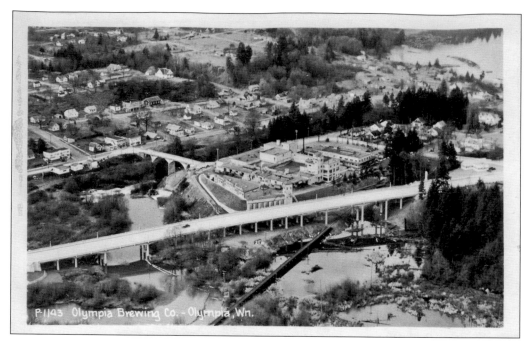

P-1143 Olympia Brewing Co. - Olympia, Wn.

The automobile motored into the South Sound region in the 1920s, bringing with it the need for modern roads to accommodate travelers. The state's first large scale road building program established Pacific Highway 99 which ran through Tumwater. The new roadway roared by the brewery, through many houses, and forced the relocation of some businesses. The mid-1930s saw the building of the current Capitol Way Bridge. The above RPPC is an aerial view of Tumwater just after the completion of the bridge. The upper portion of the photograph displays Tumwater prior to the coming of the freeway in 1958. Below is a late-1960s printed-postcard view of the same area. (Above courtesy of Paul Longcrier.)

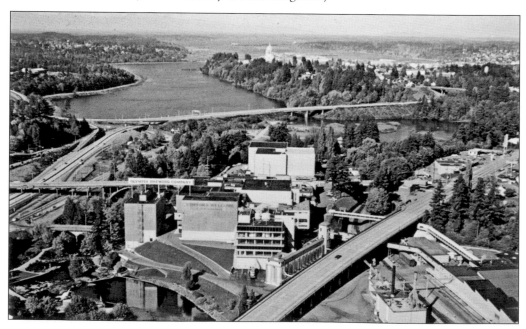

Eight

LOGGING
THE LIFEBLOOD

For the first settlers, the dense stands of timber confronting them in the Lower Puget Sound basin were a barrier to settlement. In the early years, the new arrivals could not support themselves with locally produced foodstuffs without having cleared land upon which to raise crops. The great trees had to be cut and removed to make way for agriculture; the land had to be logged. From this necessity, one of the earliest basin industries was born and the production of lumber for export began.

To clear the land, animal power in the form of oxen and horses was used to drag the bucked logs down to the water over skid roads. Their range was limited to about 1 mile from the water's edge. At first, these logging camps were located adjacent to lakes or on the shores of Puget Sound. Loggers felled trees directly into the water as the water offered easy transport to the sawmills. In the early days of Olympia, the salt water came up as far as Union Street. From atop the hill at East Fourteenth Street, logs were rolled over the edge to be floated to the bay area.

There were 40 logging camps located around Olympia in 1889, with approximately 800 men in employ. Three sawmills and a planning mill were active in processing the timber. The downtown waterfront boasted the largest log boom in the world.

In the latter decades of the 19th century, the timber industry grew dramatically. The growing economy of the Washington Territory fueled building booms and demand. The coming of the Transcontinental Railroad provided national connections and access to the international market as well. New technology was developed for the logging process, and the narrow-gauge railroad was introduced into the surrounding foothills.

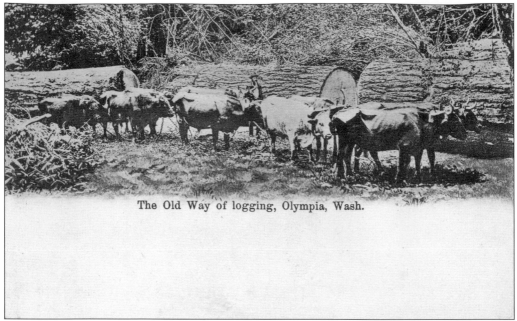

The Old Way of logging, Olympia, Wash.

In the 1880s, logs were hauled in from the woods to water by oxen and horse teams over skid roads. The *c.* 1910 printed postcard above shows "The Old Way of logging" with an oxen team of 10 chained together to haul out big timber near Olympia. The below *c.* 1910 RPPC image shows a six–horse team transporting a "10 Foot Fir" loaded on a wagon bed. The photograph was taken by noted area photographer S. H. Price of Oakville, Washington. As the easily accessible timber stands were depleted, it became necessary to expand into the Puget Sound foothills. Many early operations were abandoned or suspended, as the transport was too arduous and costly due to the limited technology of the time.

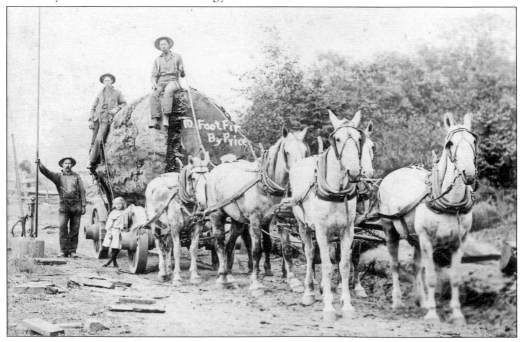

This family enjoys a lighthearted moment in the woods. Two children are perched upon the back of a dapple gray horse that is standing atop a cut log. Neither the children nor mom or dad look too at ease with the situation. The horse appears to be the least concerned. This *c.* 1910 RPPC bears the information, "Log, 7 feet in diameter—Stump, 14 ft. high." (Photograph by Hobson.)

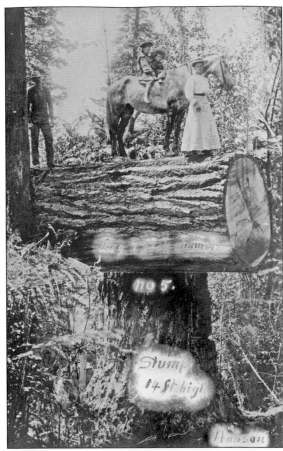

A crew of three men, along with two boys, is shown in front of a stack of fir trees in a small lumber camp in western Washington, as depicted in this *c.* 1910 RPPC view. The smaller boy is perched on a log pile near the two men at the center of the image. Three pairs of horse teams are visible in the foreground. The older boy is mounted on one of the horses on the horse team at right.

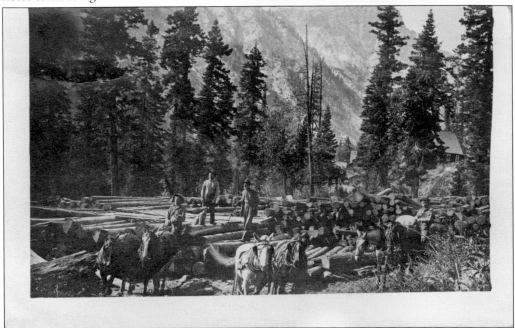

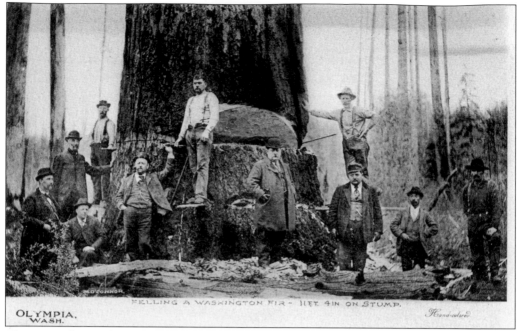

The men who performed the initial harvesting of trees in the woods for ultimate processing have long been referred to as "lumberjacks." The term generally refers to the men of a bygone era, when hand tools were used in the virgin forests. This *c.* 1910 printed postcard is captioned, "Felling a Washington Fir—11 Ft. 4 In. on Stump. Olympia, Wash."

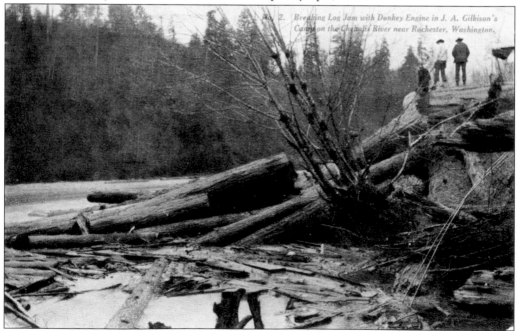

The term "river rat" was used for loggers who were employed in driving logs down a river. Sometimes the logs piled up or got snagged in low water or by rocky obstructions, creating a logjam. This *c.* 1910 printed postcard shows "Breaking Log Jam with Donkey Engine in J. A. Gilkison's Camp on the Chehalis River near Rochester, Washington."

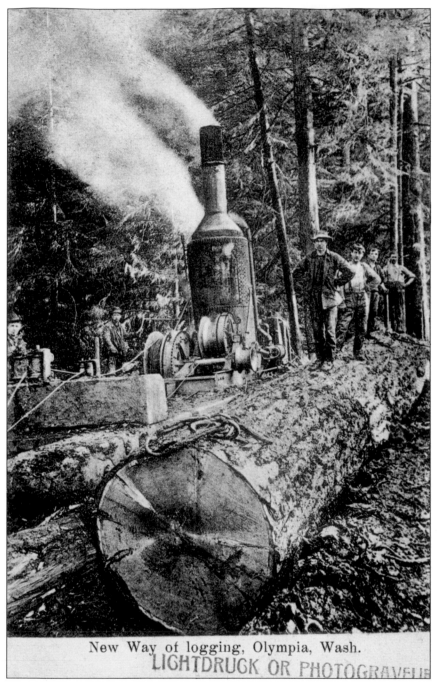

New Way of logging, Olympia, Wash.

LIGHTDRUCK OR PHOTOGRAVEUR

As the logging operations moved deeper into the foothills, the need for better methods of transportation became apparent. One solution was the donkey engine, which was invented in 1881. Powered by a steam engine, cables pulled logs in from the woods over the skid roads. The donkey engine made it possible to move logs over longer distances at a more rapid pace and at a lower cost. No animal stables or feed were needed, resulting in less expense. No ground was too wet, no hill too steep—it was a revolution in the early logging industry. This view, taken from a *c.* 1910 printed postcard, shows a donkey engine moving logs near Olympia.

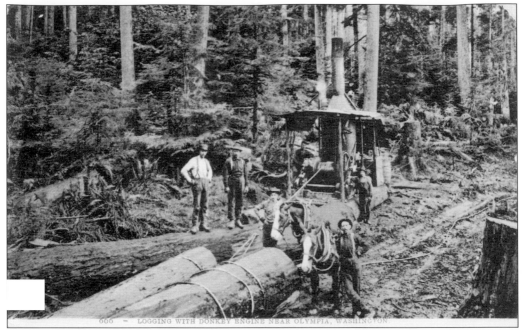

This *c.* 1910 printed view is captioned, "Logging With Donkey Engine near Olympia, Washington." Note the logs lying in the skid road. The term originated in the way harvested logs were once transported. Logs could be "skidded" down hills or along a corduroy road. The name and its meaning morphed into the modern term "skid row," referring to a place frequented by people down on their luck.

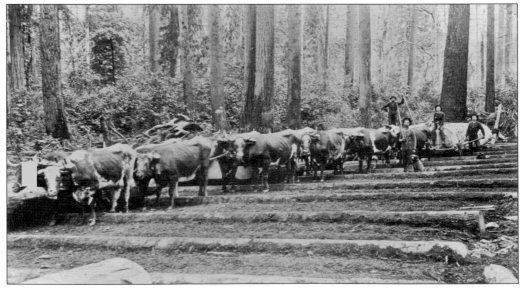

This *c.* 1910 photograph shows oxen drover George Brazil with his team moving logs over a "corduroy road." He was the father of Mrs. McKnight who—along with her husband, Joe—operated the McKnight Photo Studio in Olympia 1920–1946. This picture was taken in the woods at Bordeaux and provided the pattern that was used for the bronze relief seen at the entrance of the state legislature building. (Courtesy of State Library Photograph Collection, Washington State Archives.)

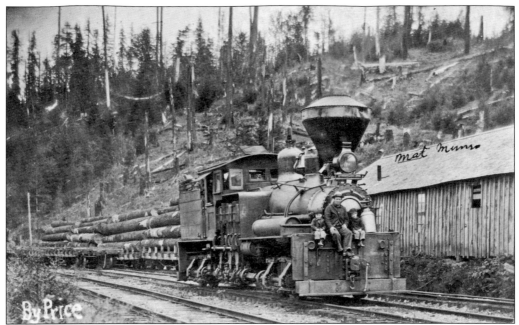

The donkey engine helped, but the problem of transporting logs from the deep woods to tidewater remained. On Lower Puget Sound, many streams were unsuited for river drives. The problem was solved by the introduction of the logging railroad. With the advent of the narrow-gauge rail, a small railroad line began hauling logs in from the foothills to the Olympia area as early as 1881. This RPPC was postmarked from Olympia in 1908. (Photograph by S. H. Price of Oakville; courtesy of Mike and Kathy McLean.)

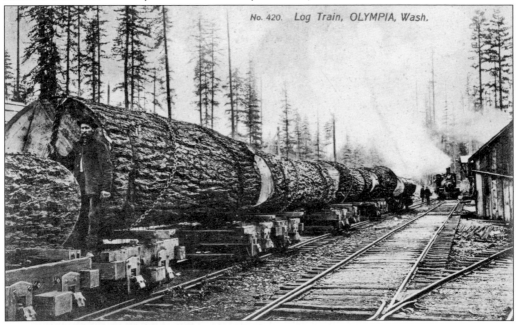

Large single logs are chained to flat cars in this *c.* 1910 printed-postcard view, "Log Train, Olympia, Washington." The message penned on the back of this postcard notes, "these logs is as large as a boxcar is on the Sant(a) Fe Railroad so there is some lumber in one of them."

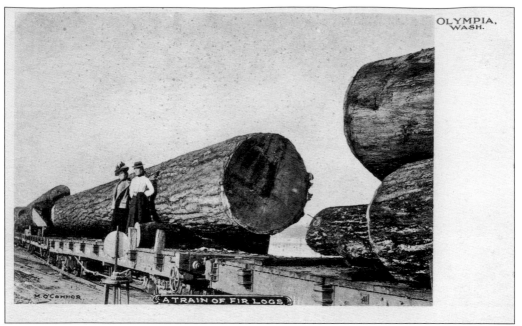

Above, the *c.* 1905 printed view shows "A Train of Fir Logs, Olympia, Wash." The card was published by M. O'Connor, a local merchant. Note the glimpse of the bay showing between flatcars. High-quality export materials included spruce, cedar, and douglas fir. Hemlock, being splintery and soft, was used primarily for temporary structures and industrial buildings. In the logging camps, it was used for constructing the skid roads. Logging camps moved away from the water, and logging communities sprang up in the woods, moving deeper and deeper into the hills. Below, the *c.* 1910 printed view shows "Washington Toothpick, 9 ft. in Diameter on Nor. Pac. R.R. Olympia, Wash."

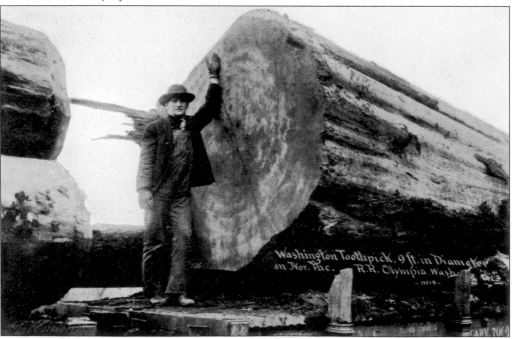

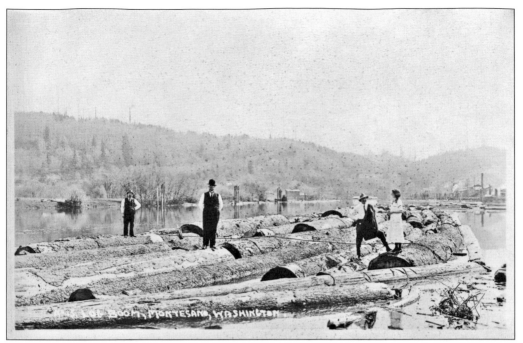

After the logs had been navigated downstream or brought in by railroad, they were held in log booms or holding ponds to await shipping or processing at the sawmill. The RPPC above shows adventuresome frolickers walking on the logs at one such pond in this *c.* 1920 image captioned, "Log Boom, Montesano, Washington." A log boom was a place where floating logs were collected and chained together to prevent their escape into open waters. Below, the *c.* 1915 printed postcard purports, "Along the Water Front, Olympia, Wash. Showing the largest boom in the world."

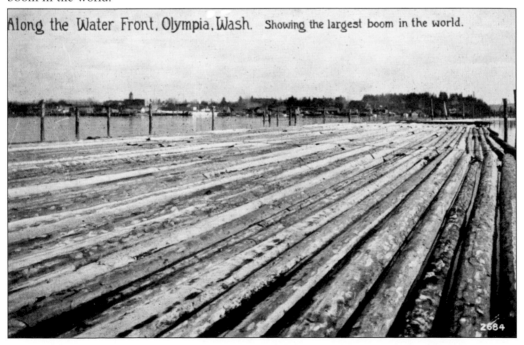

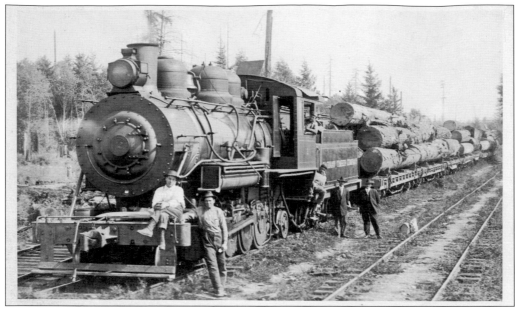

The logging communities proliferated throughout the region as tracks were laid. As many operations were in remote areas requiring significant amounts of labor and infrastructure, lumber companies often built at least one store, a cookhouse, and lodging facilities. At the turn of the century, A. J. Morley came from Saginaw, Michigan, to the land of big timber and established a logging camp in the Elma area. This *c.* 1910 RPPC image shows a train full of logs from camp one.

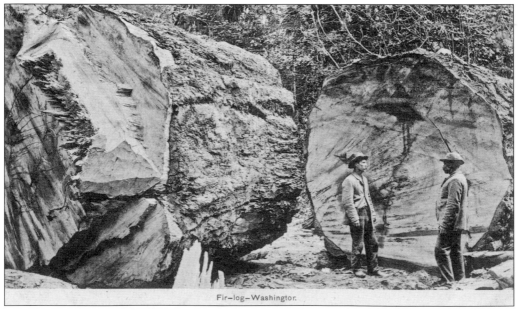

Fir—log—Washington.

This *c.* 1910 image is an indicator of the large-scale girth of some trees that were standing locally when the settlers first arrived here. The immensity of the forests must have been stunning to comprehend, the labor to cut and remove them almost impossible to muster. The two men in this image are dwarfed by the trees that have fallen in the logger's swath. Workers in Olympia's mills and forests were the highest paid in the national lumber industry.

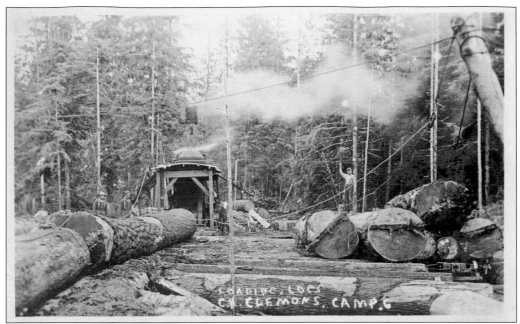

The above view, taken in the woods, shows a steam donkey at work with a row of logs going down the skid road at the C. H. Clemons Camp. First organized in 1903, Charles H. Clemons was the first president of this company operating in the Montesano area. It had approximately 21 miles of railroad track. In 1918, it reorganized as a wholly owned subsidiary of the Weyerhaeuser Timber Company. The organizers were Charles and Minot Davis. Hugh Stewart was a trustee. The track area then extended to 75 miles. In 1936, the company was merged into the Weyerhaeuser Timber Company, and the Clemons Logging Company was dissolved in 1937. In 1941, the original logging site was dedicated as the first tree farm in Washington. The lower image shows logs being dumped from railroad train flatcars into the Chehalis River at Melbourne, C. H. Clemons Camp.

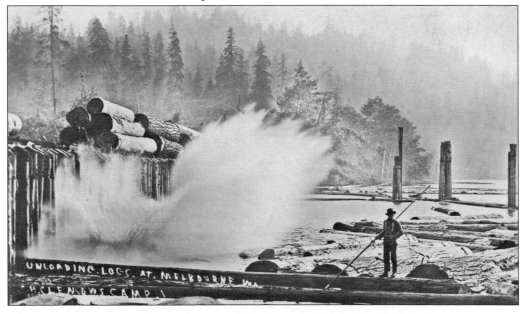

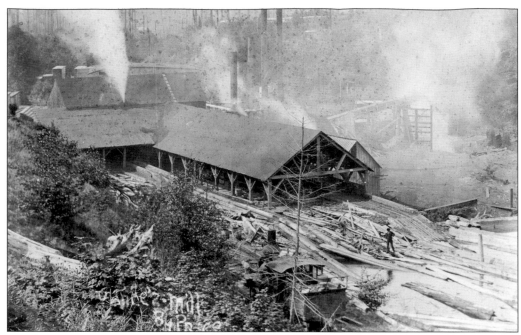

Small loggers could not afford the expense of railroad construction and operation, so the logging industry was brought increasingly under the control of large firms. Vance's Mill, shown above, was located at Malone on the Chehalis River, between Oakville and Elma. The 1908 message on reverse by noted photographer S. H. Price says, "I am sending you your post cards with this 4½ dozen in all. Do you think you would like any like this one. It is Vance's Mill and would be a good seller I think. S.H. Price." Below, Mutual Lumber Company, "The Big M," was founded in 1902 by Martin Foard, Frank R. Stokes, W. W. Whipple, and F. D. Butzer. Butzer and Whipple withdrew in 1903 and were replaced by Perry F. Knight. This mill produced 120,000 board-feet of lumber per day, until the complex was destroyed by fire in 1912. (Courtesy of Richard Dreger.)

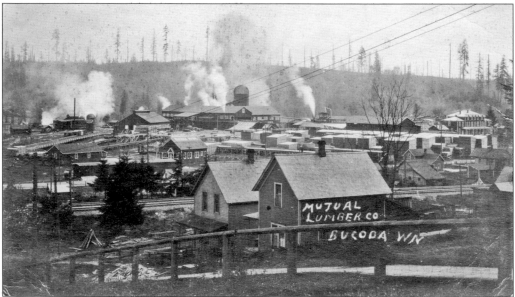

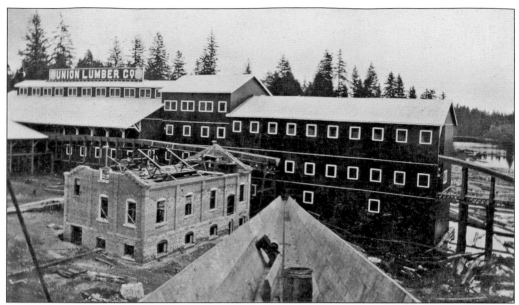

The Union Lumber Company in Lacey, shown above, was one of the first electric sawmills in the northwest when it was built in 1912. At peak capacity it produced 120,000 board-feet of lumber per day. To provide for its hundreds of workers, Union Mills became a small mill town with living accommodations, a store, post office, pool hall, and barbershop. Community entertainment was provided in the form of movies, dinners, talent shows, and dances. The mill closed after a fire at its timber source in Bucoda in 1925 and was dismantled. Today it is a Weyerhaeuser site. Below, Shelton merchant Mark Reed teamed up with Henry McCleary to build two lumber mills in 1924. Reed was elected mayor and later to the state legislature, becoming one of the states most powerful politicians. He was a champion of Washington's groundbreaking Workman's Compensation Act. (Above courtesy of Paul Longcrier; below courtesy of Richard Dreger.)

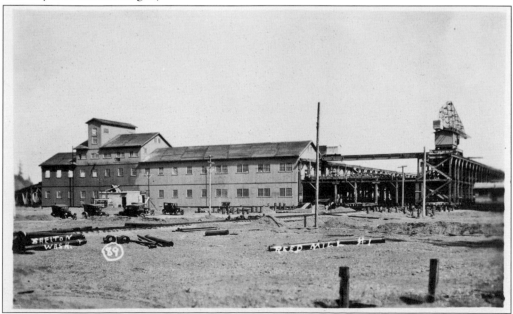

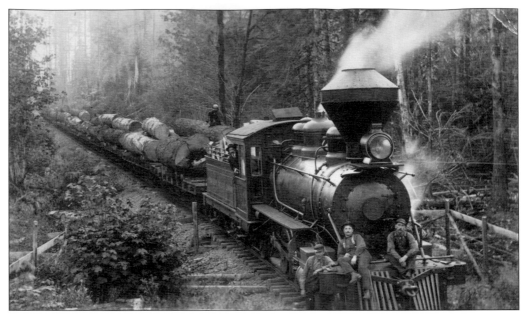

The Puget Sound and Grays Harbor Railroad with terminus near Shelton extended to Montesano on the Chehalis River. The Satsop Railroad snaked for a dozen miles into the nearby hills toward Olympia. Mason County soon became the center of Washington railroad logging and the surrounding forestland was a primary source of logs rafted to Olympia. Trains made it all happen. The image shows a logging train in the woods near Shelton.

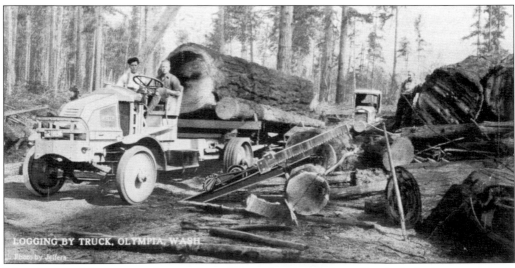

The advent of the automotive age brought another revolution of technical advancements in the logging industry with the introduction of the logging truck. Other petroleum-operated machines soon followed, and Olympia remained an important exporter of logs and lumber for decades to come. This *c.* 1925 printed-postcard image gives a visual picture of that advance in "Logging by Truck, Olympia, Wash." A new age had begun.

BIBLIOGRAPHY

Lockman, Heather. *Building a Capital City: Olympia's Past Revealed Through Its Historic Architecture.* Olympia, WA: Capital City Press, 2000.

Newell, Gordon. *A History of Olympia and Thurston County, Washington.* Olympia, WA: Gordon Newell and F. George Warren, 1987.

Newell, Gordon. *Rogues, Buffoons & Statesmen.* Seattle, WA: Hangman Press and Superior Publishing Company, 1975.

Stevenson, Shanna B. and Olympia Historic Preservation Committee. *Preliminary Survey of Olympia's Historic Resources.* Olympia, WA: Olympia Planning Department, 1982.

Stevenson, Shanna B. and Olympia Heritage Commission. *Downtown Olympia's Historic Resources.* Olympia, WA: Olympia Planning Department, 1984.

Stevenson, Shanna B. *Olympia, Tumwater, and Lacey: A Pictorial History.* Virginia Beach, VA: The Donning Company, 1996.

www.arcadiapublishing.com

Discover books about the town where you grew up, the cities where your friends and families live, the town where your parents met, or even that retirement spot you've been dreaming about. Our Web site provides history lovers with exclusive deals, advanced notification about new titles, e-mail alerts of author events, and much more.

MADE IN THE USA

Arcadia Publishing, the leading local history publisher in the United States, is committed to making history accessible and meaningful through publishing books that celebrate and preserve the heritage of America's people and places. Consistent with our mission to preserve history on a local level, this book was printed in South Carolina on American-made paper and manufactured entirely in the United States.

This book carries the accredited Forest Stewardship Council (FSC) label and is printed on 100 percent FSC-certified paper. Products carrying the FSC label are independently certified to assure consumers that they come from forests that are managed to meet the social, economic, and ecological needs of present and future generations.

FSC
Mixed Sources
Product group from well-managed forests and other controlled sources

Cert no. SW-COC-001530
www.fsc.org
© 1996 Forest Stewardship Council

Find Your Place in History.